# DIEGO VELÁZQUEZ

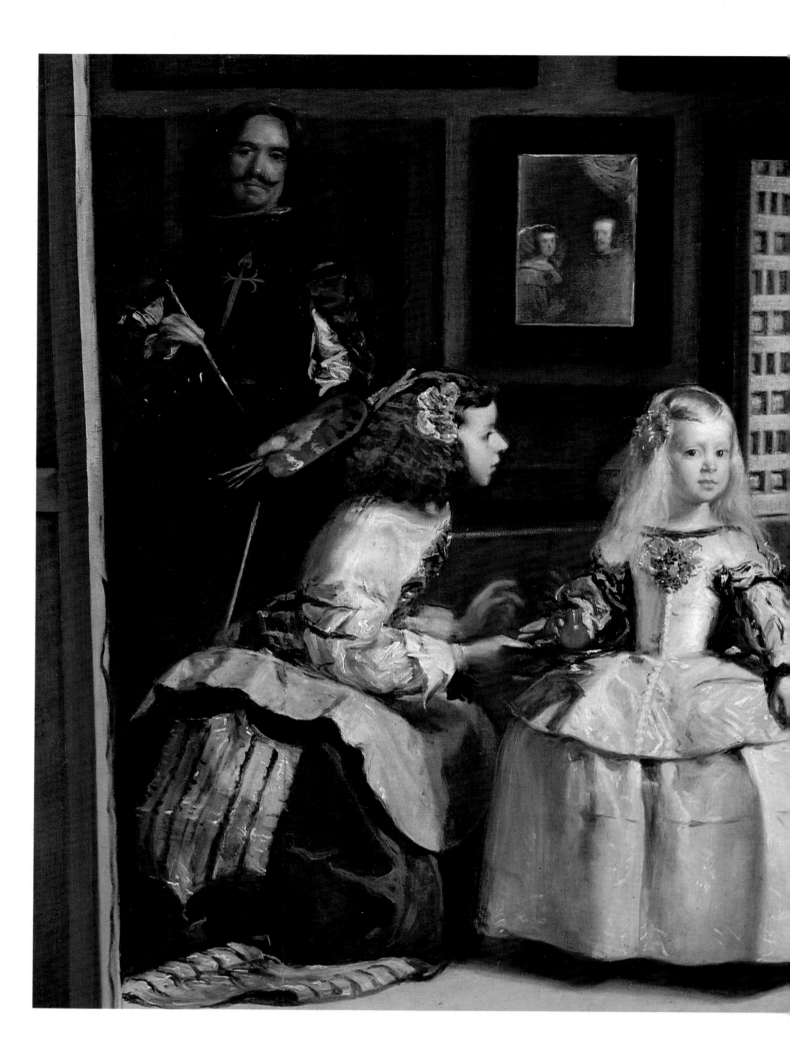

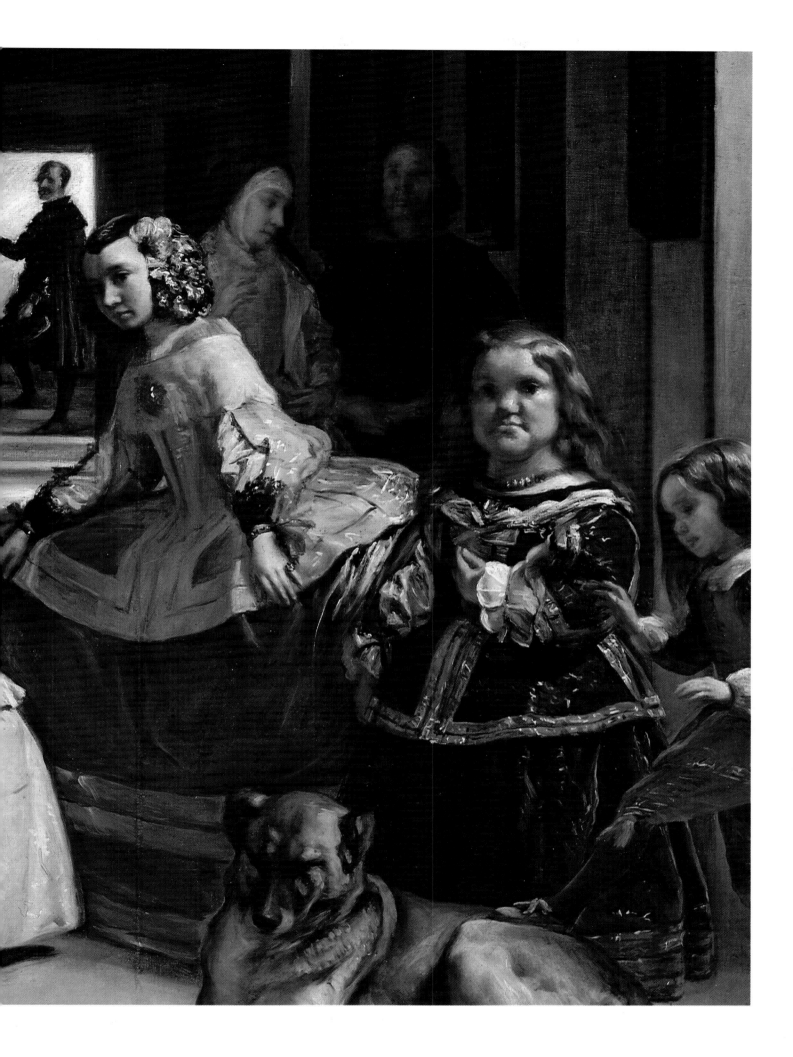

Designed by Yevgeny GAVRILOV
Translated from the Russian by Alexandra GEORGE
Edited by Tatyana MORDKOVA
and Yelena TABANIUKHINA (English text)
Editor's assistant Yelena SHIPOVA
Computer type-setting by Emile KAN

ISBN 185 995 221 6

Printed and bound in Italia

# DIEGO VELÁZQUEZ

*Liudmila Kagané*

PARKSTONE PUBLISHERS, BOURNEMOUTH
AURORA ART PUBLISHERS, ST PETERSBURG

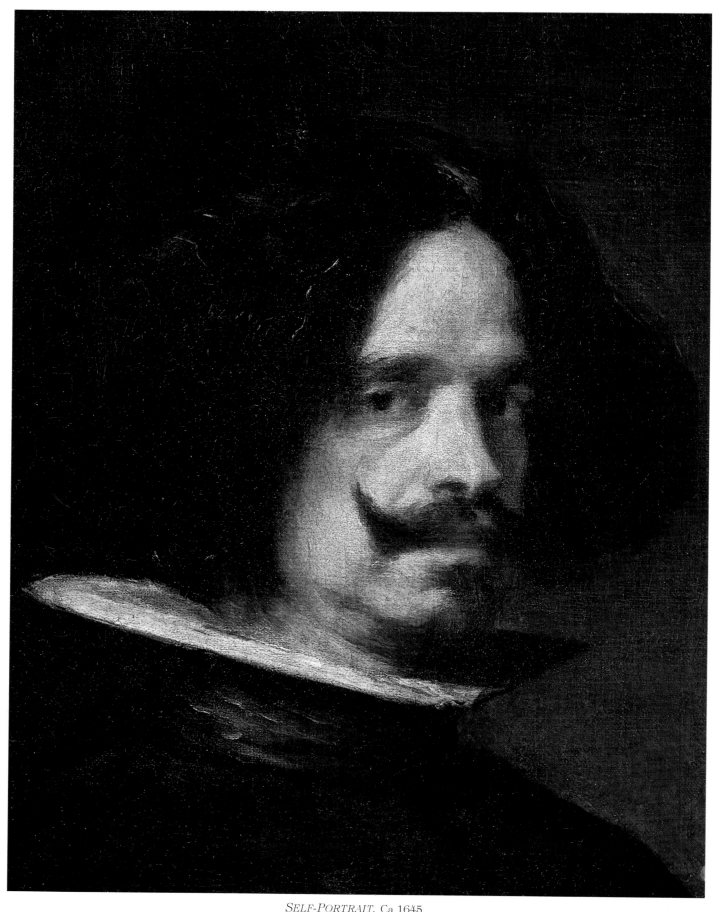

*SELF-PORTRAIT.* Ca 1645
Oil on canvas. 45 x 38 cm
Museo Provincial de Bellas Artes, Valencia

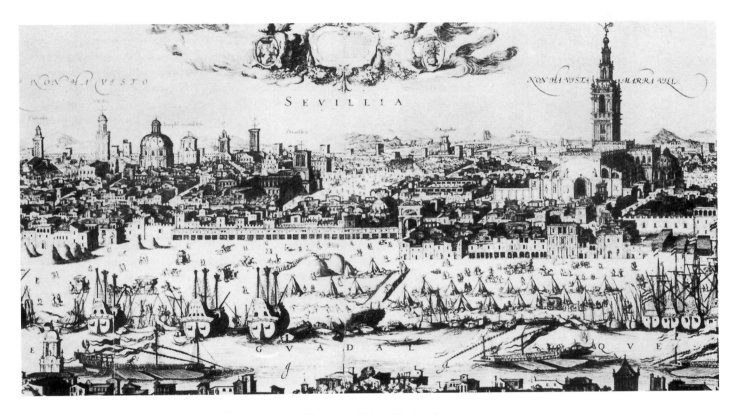

*VIEW OF SEVILLE.* 1617
Detail of an engraving

Spanish art flourished and reached its highest peak in the seventeenth century. Throughout the country the best artists were at work – architects, sculptors and painters. In the late sixteenth and early seventeenth centuries El Greco's art shone forth brilliantly in Toledo. He was a master uniting both the Byzantine and Italian heritage, who found a spiritual milieu for his religious, philosophical and moral convictions on the Iberian Peninsula. In Naples, Jusepe de Ribera from Valencia, one of the staunchest followers of Tenebrism, a manner of painting initiated by Caravaggio, was renowned. His art was filled with true Hispanic passion and religious tension. In Seville Francisco de Zurbarán, and later, Bartolomé Esteban Murillo, decorated numerous monasteries and churches with religious canvases, giving visual expression to the ideals of their contemporaries. Velázquez holds a special place in this constellation of great masters on account of the unusual versatility of his art, reflected in both the content and the stylistic originality of his work.

7

Diego Rodríguez de Silva Velázquez, a native of Seville, the capital of Andalusia, was christened on 6 June 1599. His parents, Juan Rodríguez de Silva and Doña Gerónima Velázquez, belonged to the minor nobility but were far from wealthy. According to the Andalusian custom, the son adopted his mother's surname. At the beginning of the seventeenth century Seville was a wealthy trading port, attracting adventurers from all corners of Europe. From here, ships set out to the New World and returned with untold treasures. In the streets of the busy town, the crowds communicated in a medley of languages; a love of theatre, music and literature prevailed. Seville was the leading religious centre of Andalusia; more than forty monasteries and convents, numerous churches, religious fraternities, hospitals and alms houses competed with each other in decorating their premises with works of art. But the cathedral, of course, surpassed them all, being a veritable treasure-house of art. When he was ten, Velázquez began his training with the Sevillian painter, Francisco Herrera the Elder. He was only there for a short time however, since in December 1616 his father approached Francisco Pacheco, with whom he signed a contract in September of the following year regarding his son's training. Pacheco was a respected artist in Seville who had obtained important commissions, although he demonstrated no particular talent. His merit in regard to Velázquez's

Unknown Spanish artist of the 17th century
*THE ALAMEDA DE HERCULES, SEVILLE*
Private Collection

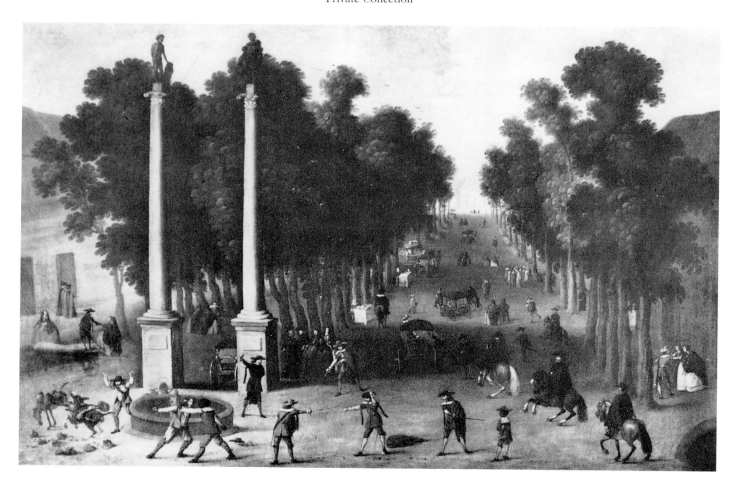

education lay in the fact that he, better than any other, was able to acquaint his pupil with the higher accomplishments of European culture. From the 1560s, the city boasted an "academy" of which Pacheco's uncle – a canon of the Seville cathedral, who also bore the name Francisco Pacheco – was a member. The Seville Academy was organized along the lines of the Italian Humanist circles of the fifteenth century. Its founder was Juan Mal Lara, a disciple of Erasmus of Rotterdam. The members of the Academy studied classical languages, history and literature. After the death of Mal Lara in 1571 three people headed the circle, one of whom was Canon Pacheco. His nephew, the artist Francisco Pacheco, replaced him by right of succession. From then on, questions relating to art became one of the Academy's principal concerns. Thus, undertaking his training with Francisco Pacheco, Velázquez not only mastered the skills of painting, but also came into contact with the most illustrious names in Seville. Among the members of the Academy was the famous collector and patron of the arts, Fernando Henríquez Afán de Ribera, the third Duke of Alkalá, whose palace, the "Casa de Pilatos", was a veritable museum. In ancient times, Spain had been a province of the Roman Empire and the country never forgot its historical heritage. According to legend, Seville was founded by Hercules, something which caused the citizens a special pride. On one of the city's central lanes there were columns bearing statues of Hercules and Julius Caesar. However, the Spanish were discriminating in their adoption of the classical heritage: those elements of paganism which ran counter to Christian morals were anathema. During the Renaissance period in Spain, Classical Antiquity did not become the basis for the development of a new form of art as it did in Italy. Nevertheless, classical scholarship was recognized and respected.

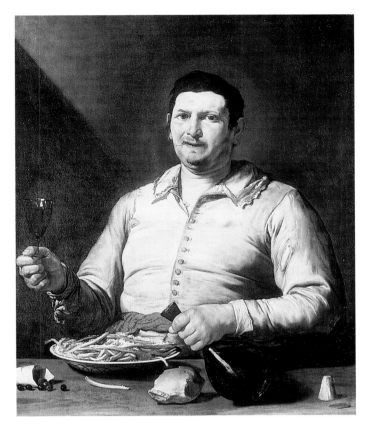

Jusepe de Ribera
*THE SENSE OF TASTE.* Ca 1614-16
Oil on canvas. 113.6 x 88.3 cm
Wadsworth Atheneum, Hartford, Connecticut

With regard to the Italian Renaissance, Francisco Pacheco was a great admirer of Leonardo da Vinci, Raphael, Michelangelo, Titian and other famous masters. Pacheco devoted many years of his life to the writing of the book *Arte de la Pintura*. It was completed in 1638, but only published ten years later. The ideas and concepts presented in the book were nurtured by Pacheco during the period when Velázquez studied under him. One of Pacheco's principal ideas – the nobility and virtue of the art of painting – played a key role in the formation of Velázquez's profound consciousness as a painter. While eulogizing the classical art of the Renaissance, Pacheco nonetheless also paid tribute to the new realistic trend emerging in painting. In Italy, Michelangelo Merisi da Caravaggio, who rapidly gained

9

many admirers, was the movement's principal founder. It is not known which of Caravaggio's or his followers' works found their way to Seville in the 1610s, but it seems fairly certain that they did appear there, since it would otherwise be difficult to account for Velázquez's early works, which clearly betray the influence of Tenebrism, the use of striking effects of lighting, especially strong shadow, typical of Caravaggio. The works of Ribera featuring allegories of the five senses, executed in Rome in 1613 and 1614, could have equally been produced in Seville.

Wishing to better acquaint himself with contemporary art in Spain and with the royal collection, in 1611 Francisco Pacheco undertook a journey to Madrid, the Escorial and Toledo. Italian and Netherlandish masterpieces, collected over the course of a century, were kept in the royal collections. By the beginning of the seventeenth century, the Escorial was one of Spain's main artistic centres, where many painters, both locals and incomers, worked. Toledo had still not lost its significance as the ancient capital. Pacheco visited the studio of El Greco. The works of the artist produced a strong impression on him: he had a particularly high esteem for the depictions of saints and the portraits. Pacheco himself worked on a book of portraits of his fellow-countrymen for many years, creating drawings and annotating them with texts. In Toledo, Pacheco may have met Juan Bautista del Maino, who had recently returned from Italy and was one of those influenced by Caravaggio's art. There is no doubt that on his return to Seville, Pacheco shared his impressions of his journey with the learned members of the Academy and his pupils. It is quite likely that he brought sketches and some works back with him.

Finally, Pacheco was highly knowledgeable on matters of iconography. A substantial part of *Arte de la Pintura* is devoted to the description of how religious subjects should be depicted. In this respect he was a champion of the dictates of the Council of Trent, which exhorted artists to create means of disseminating religious ideas in works that were accessible to the common people. Moreover, Pacheco was Inspector of Art for the Inquisition and artists were obliged to follow his directions. However, it must be said that the descriptions of religious events in Pacheco's book are written with unusual vividness, with life-like details and in the general spirit of ingenuous perception characteristic of an artist of his era. Censorship was evidently not too strict, since manifest divergences from Pacheco's directions can be found in the works of many of Seville's artists.

The preceding pages indicate the significance of the years Velázquez spent with Pacheco. Intensive studies probably began in 1612, since Pacheco himself wrote that Velázquez's training lasted five years. On 14 March 1617 Velázquez took the examination to become a master painter and received the right to work independently. A year later, on 23 April 1618, he married Pacheco's daughter, Juana de Miranda, who was then sixteen. The following year their daughter Francisca was born followed in 1621 by another daughter, Ignacia.

The production of religious works of art was the principal task of Sevillian painters, and Velázquez was naturally trained in this field. Already in his apprentice years, however, he exhibited an unusual proclivity for the depiction of real life. Pacheco recounted how Velázquez specially hired a peasant boy so that, observing him crying at one moment and laughing the next, he could make sketches of him.

Towards the end of the sixteenth century paintings with subjects taken from daily existence and still lifes began to appear in

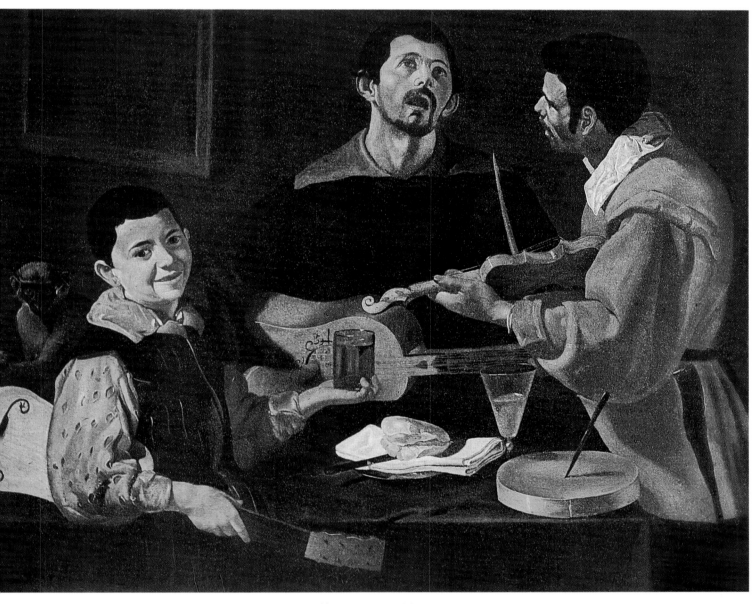

*THE MUSICAL TRIO.* Ca 1617
Oil on canvas. 87 x 110 cm
Gemäldegalerie, Berlin-Dahlem

Spain – at first by Netherlandish and Italian artists, and subsequently by Spanish painters as well. From his first years as an artist Velázquez took a great interest in everyday scenes. The earliest of his surviving works – *The Musical Trio* (*ca* 1617; Gemäldegalerie, Berlin-Dahlem) – is a genre piece, depicting a group of people enjoying themselves at a feast. Large figures loom in the foreground, while the action takes place in a dark room, illuminated by a narrowly directed source of light. Under such lighting the three-dimensional forms stand out particularly sharply, creating an illusion of tangibility. The colour range is composed of hues of yellow and brown. The still life arranged on the table is accorded much attention. The smiling boy on the left is evidently the one mentioned by Pacheco.

Paintings of this kind were very popular and Velázquez created many during his early period. One of them, *Three Men at Table*, without any doubt, depicts a tavern feast. Such paintings came to be known as *bodegones* (from the Spanish word *bodega* – "tavern"). Subsequently the term *bodegón*

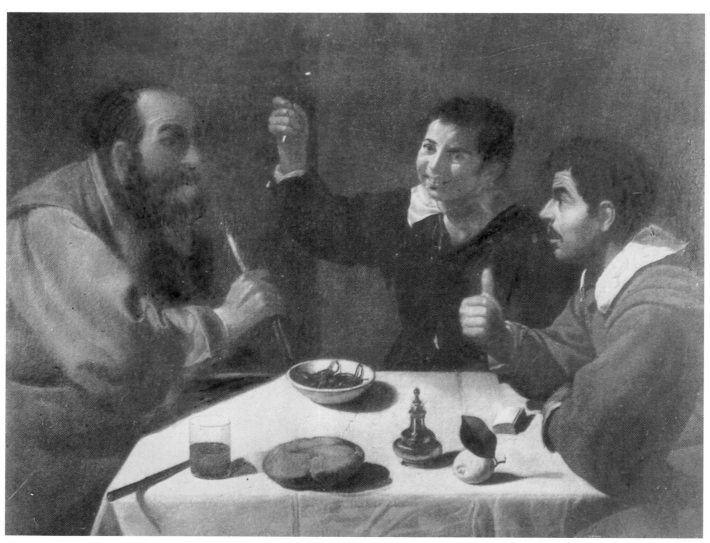

The circle of Velázquez
*THREE MEN AT TABLE*
Luis Garrouste Collection, Madrid

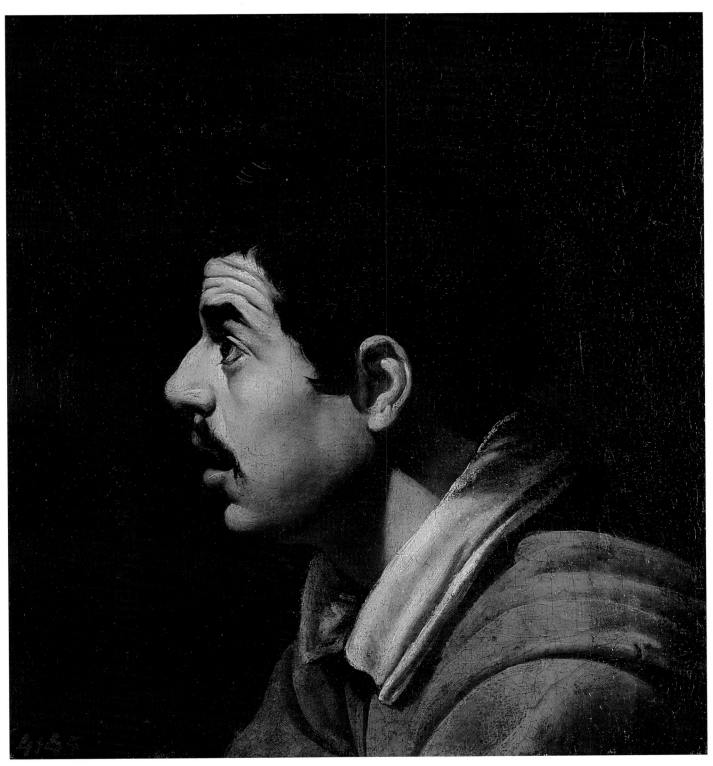

*MALE HEAD IN PROFILE.* Ca 1617
Oil on canvas. 39.5 x 35.5 cm
The Hermitage, St Petersburg

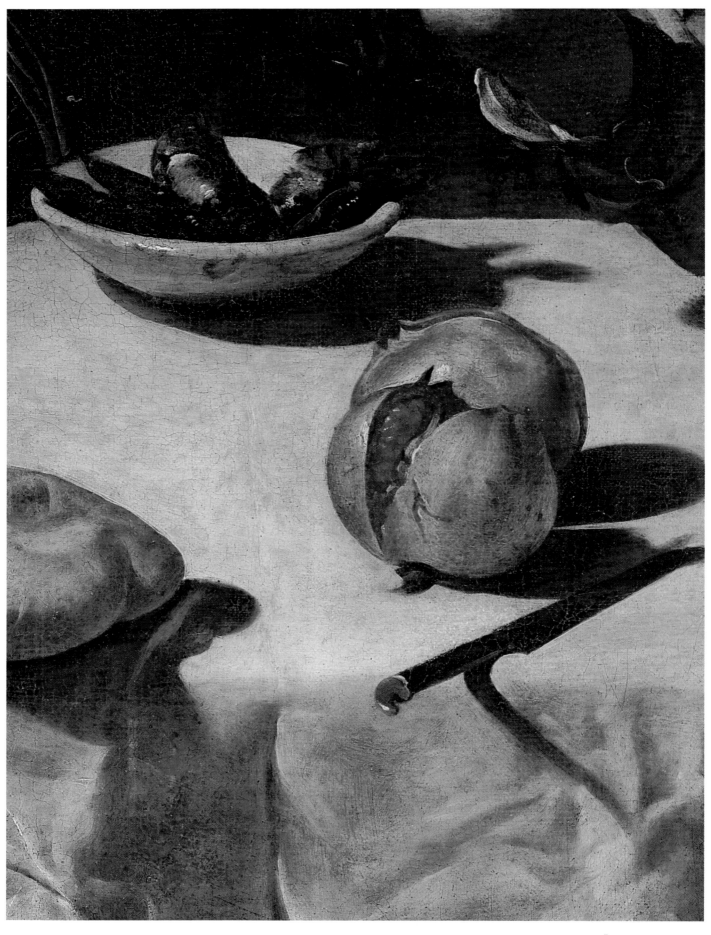

*LUNCHEON.* Detail

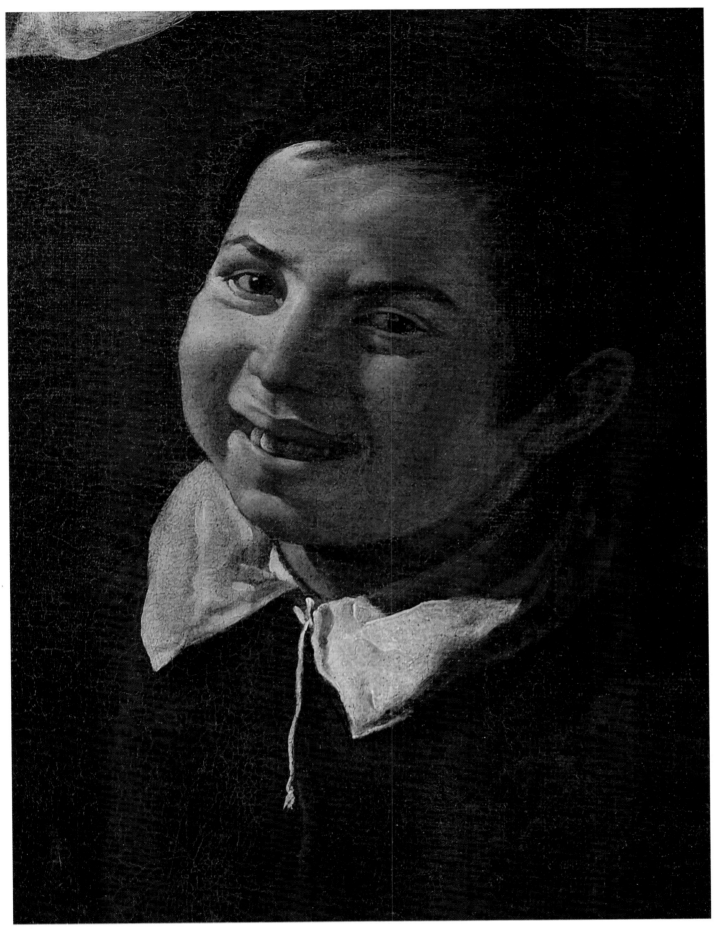

*LUNCHEON.* Detail

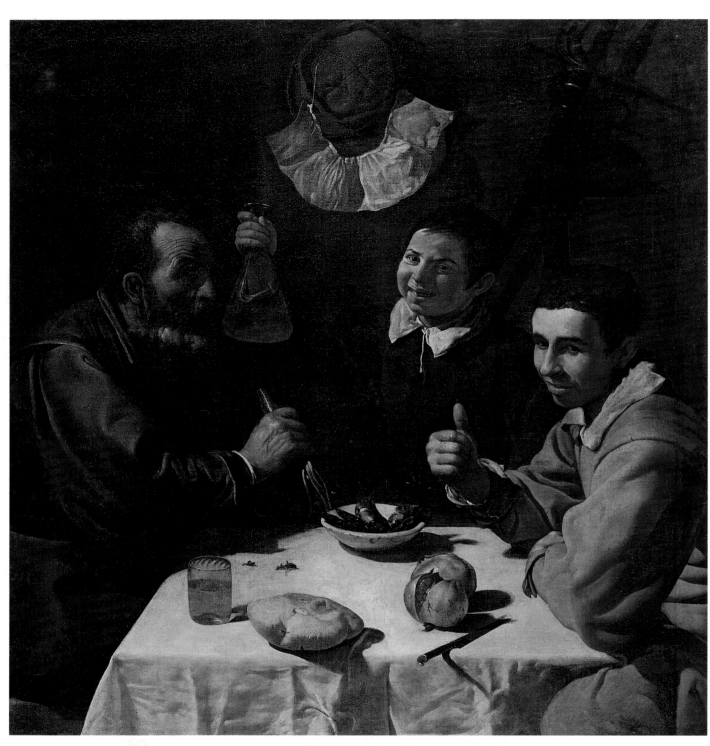

*LUNCHEON.* Ca 1617
Oil on canvas. 108.5 x 102 cm
The Hermitage, St Petersburg

was extended to other depictions of a secular nature – kitchens and still lifes. It has been suggested that the *Male Head in Profile*, now in the Hermitage, is a fragment of one of Velázquez's lost works, known only through copies. The same man figures in the work *Three Men at Table*, attributed to Velázquez's circle, belonging to the Garrouste collection in Madrid. The painting of the Hermitage piece is a testimony to the young artist's high level of craftsmanship, with its dense brushwork, rich, sparkling hues of yellow and the superbly painted white collar. The contrasts of light and shade are sharply accentuated, the wrinkles on the man's forehead are worked up rigidly. Such straightforwardness in the treatment of light and shade in painting was subsequently gradually, though fairly rapidly, toned down in Velázquez's works. *Luncheon*, another picture in the Hermitage, dated to the period around 1617, can be attributed to the next stage of

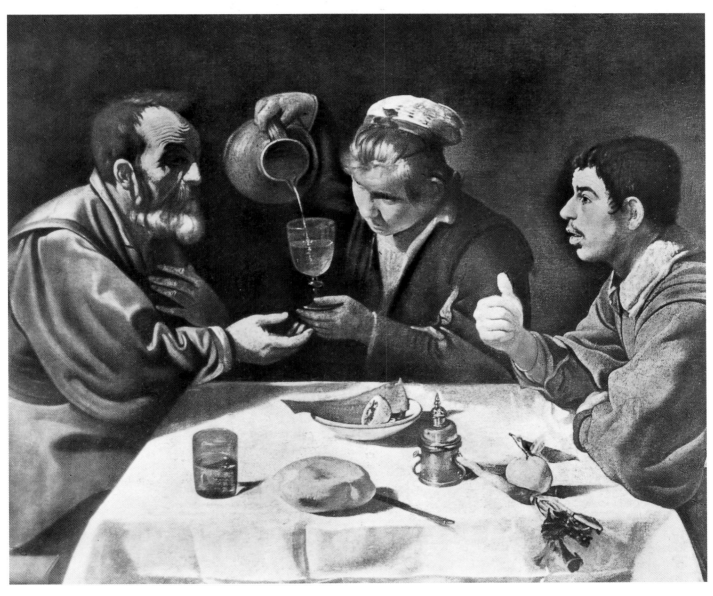

*TWO MEN AND A WOMAN AT TABLE*. Ca 1618
Oil on canvas. 96 x 112 cm
Museum of Fine Arts, Budapest

Velázquez's works. Compared to *The Musical Trio*. the composition here is more complete and integral. The boy from *The Musical Trio* appears again in the centre, but here he looks older, and his smile is far more lively and natural. The striking feeling for form in the picture and the skilfulness of the laconic evocation of three dimensions are particularly evident in the treatment of the heads of the boy and youth seated on the right. Velázquez delighted in opportunities to use chiaroscuro in painting, and here he consciously displays them. A rapier, casting a sharp shadow, hangs on the wall; a plate of fish, a piece of bread and pomegranates are arranged on the table (in the contrasting light they assume a tangible three-dimensional quality); the knife in the foreground tears the edges of the canvas asunder, as though reaching out to the viewer. Evidently a variant of *Luncheon* was executed later (*ca* 1618; Museum of Fine Arts, Budapest), being more complex in its use of hues. The work *An Old Woman Cooking Eggs* (National Gallery of Scotland, Edinburgh) is dated to 1618. The painterly manner is similar to the Hermitage *Luncheon*, but if in the latter the colours have darkened and lie under a dense layer of varnish, *An Old Woman Cooking Eggs* glistens with the beauty of yellow and brown hues and the dazzling whiteness of the plate and the eggs. Similar depictions of kitchens occur in Italian paintings of the period, such as, for example, *Interior of a Kitchen* by Pensegnante de Saraceni (earlier attributed to Caravaggio) in the Galleria Corsini in Florence. The painting's format, a still life in the foreground and a basket hanging on the wall, are parallelled in Velázquez's work. We can state, then, with certainty that during his first years as an artist Velázquez formed part of the circle embracing the most progressive trends in the painting of his day.

In *An Old Woman Cooking Eggs*. one of the characters is the boy encountered in earlier works. Here, he does not smile but has a serious, concentrated mien. This same boy is depicted in the most significant and mature of Velázquez's *bodegones* – *The Water Seller of Seville* (*ca* 1619; The Wellington Museum, Apsley House, London). Velázquez gradually passed from amusing, simple and humoristic scenes to thoughtful, serious works, which compel one to dwell on the sublimity and significance of the ordinary inhabitants of Seville who people the paintings. Simultaneously, Velázquez perfected his skills. In *The Water Seller of Seville*, the artist achieves an exceptional integrity and simplicity of compositional approach, but the texture of the objects depicted – the large earthenware jug boldly placed in the foreground, the glazed vase on the table and the glass tumbler – is conveyed with unsurpassed perfection. If *The Water Seller of Seville* is monumentally quiescent, in another *bodegón* – *Two Young Men at Table* (*ca* 1622; The Wellington Museum, Apsley House, London) – Velázquez conveys the movement of figures, as if the scene is accidentally glimpsed from the side. The sense of posing found in all

Pensegnante de Saraceni
*INTERIOR OF A KITCHEN*. 1620–30
Galleria Corsini, Florence

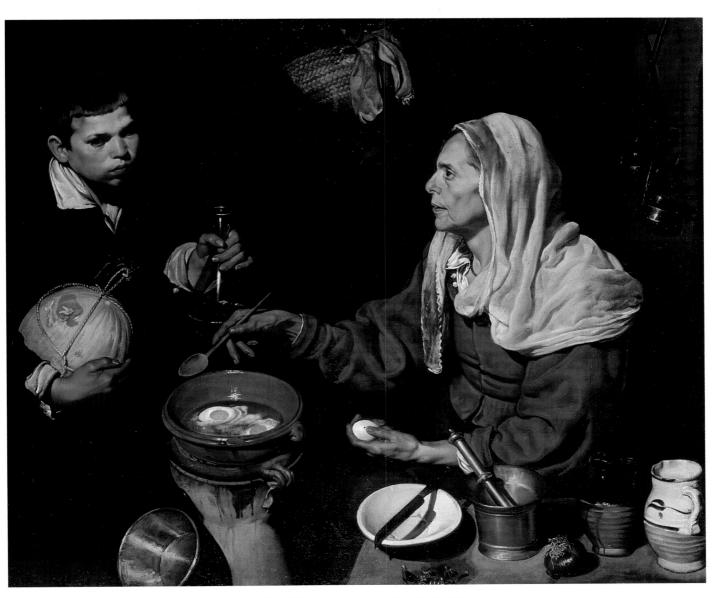

*AN OLD WOMAN COOKING EGGS.* Ca 1618
Oil on canvas. 100.5 x 119.5 cm
National Gallery of Scotland, Edinburgh

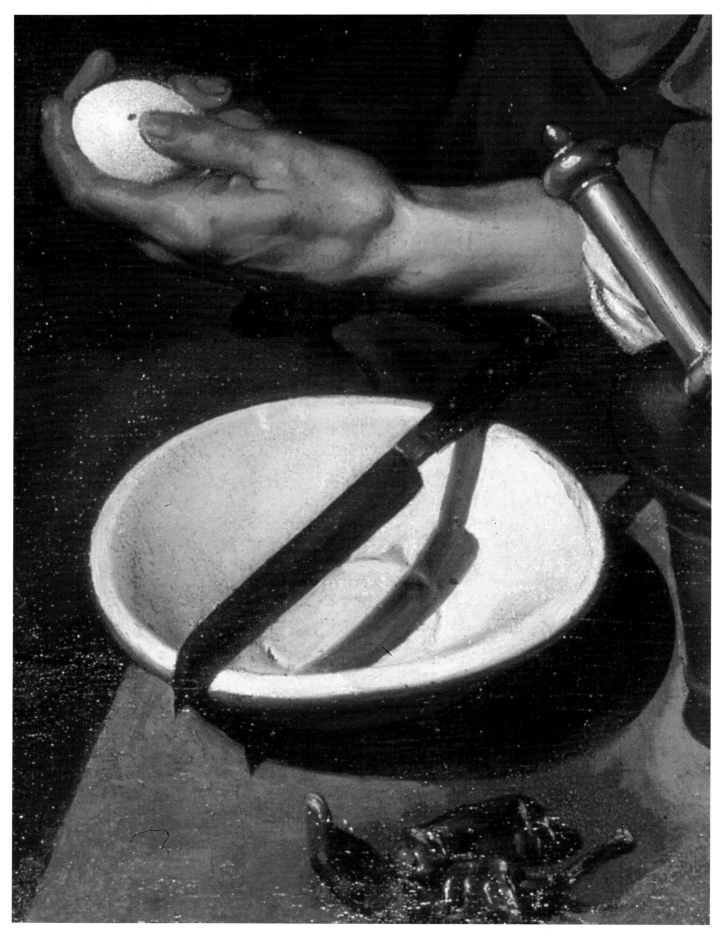

*AN OLD WOMAN COOKING EGGS.* Detail

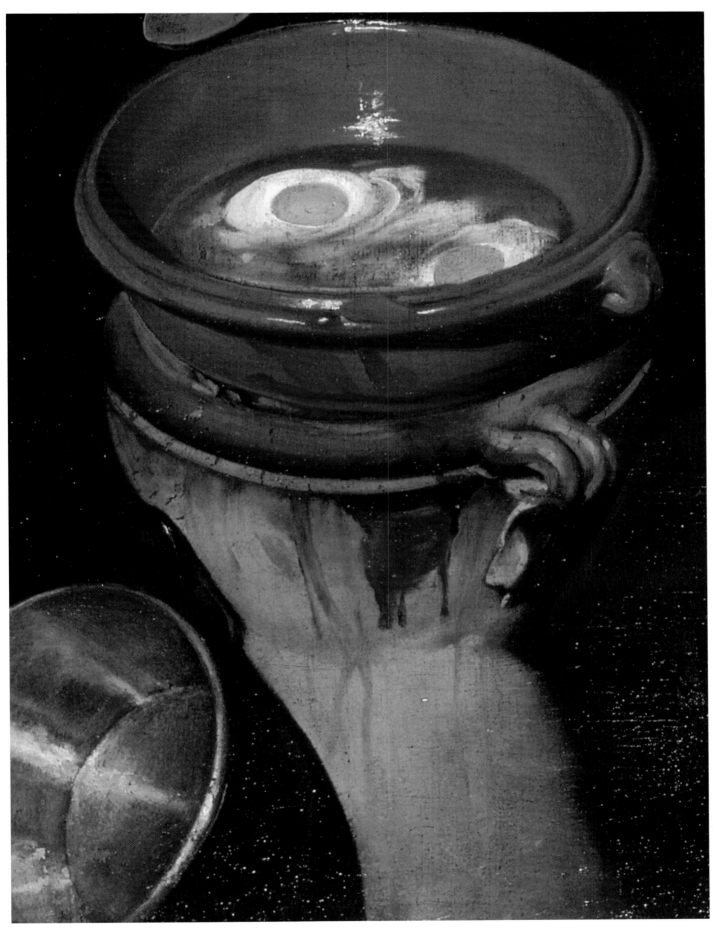

*AN OLD WOMAN COOKING EGGS.* Detail

*THE WATER SELLER OF SEVILLE.* Detail

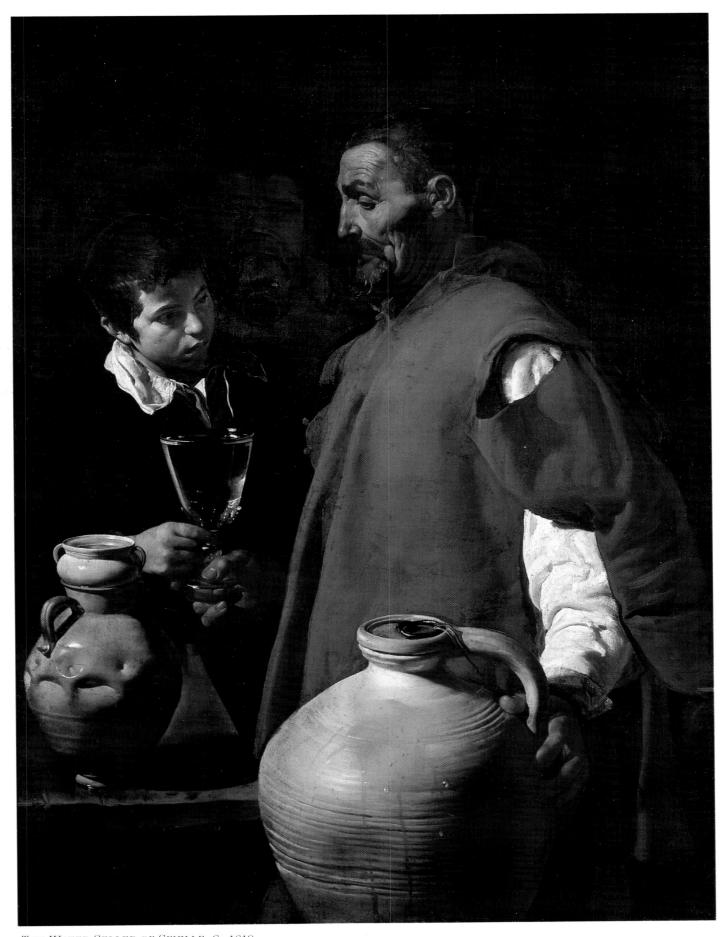

*THE WATER SELLER OF SEVILLE.* Ca 1619
Oil on canvas. 106.7 x 81 cm
The Wellington Museum, Apsley House, London

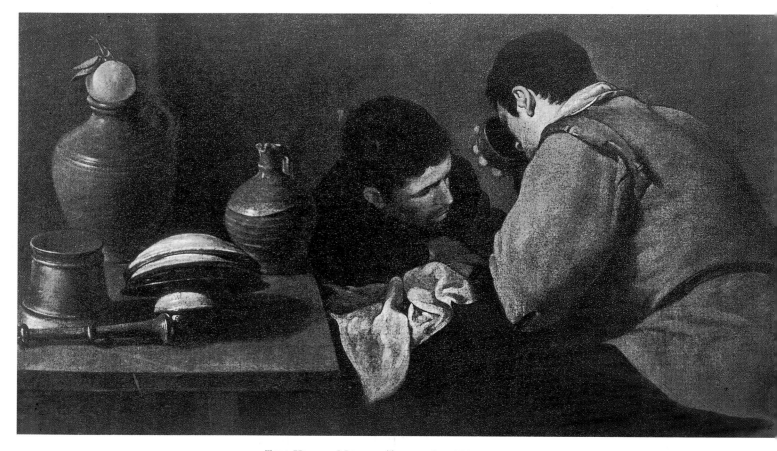

*TWO YOUNG MEN AT TABLE.* Ca 1622
Oil on canvas. 64.5 x 104 cm
The Wellington Museum, Apsley House, London

the previously examined works is here overcome, as inertness gives way to movement. Several of Velázquez's *bodegones* incorporate religious subjects, such as *Kitchen Scene with Christ in the House of Martha and Mary* and *Tavern Scene with Christ at Emmaus*. They possess a vividly expressed didactic nature. In the foreground of *Kitchen Scene with Christ in the House of Martha and Mary* (*ca* 1618; National Gallery, London), an elderly woman admonishes a young housewife. On the right is a painting within a painting – the subject of the title. Similar works, comprising genre scenes with religious undertones, were produced by the Netherlandish painters Joachim Bueckelaer and Pieter Aertsen. Their works were reproduced in engravings and were, of course, known to Velázquez. It is difficult to say whether the scene with Christ in the house of Martha and Mary is a depiction of another dwelling, or whether it is indeed a painting hanging on the wall. (It has also been suggested that it was a mirror reflecting the room). It is almost impossible to settle the matter: the frame in which the religious scene is placed resembles both the aperture of a window and a frame. The important element in this painting, however, is the intermingling of the everyday and spiritual content. In the early seventeenth century, the words of St Teresa "Dios anda entre los pucheros" (God wanders among kitchen vessels) – were widely disseminated. St Teresa (1515–1582) – a reformist nun and a writer with mystical proclivities, the author of brilliant books with descriptions of visions, possessing the vividness of naturalistic detail – had an enormous impact on Spanish society. Her beatification in 1614 was widely celebrated in Seville, and in 1622 the nun was canonized. It is not surprising that thoughts about the constant presence of God among people should have found expression in the works of Velázquez as

well. The story of Christ in the house of Martha and Mary comes from the Gospels (Luke 10: 38–42), where it is said: "... He entered into a certain village: and a certain woman named Martha received Him into her house. And she had a sister called Mary, which also sat at Jesus' feet and heard His word. But Martha was cumbered about much serving, and came to Him, and said, Lord, dost thou not care that my sister hath left me to serve alone? bid her therefore that she help me. And Jesus answered and said unto her, Martha, Martha, thou art careful and troubled about many things: But one thing is needful: and Mary hath chosen that good part, which shall not be taken away from her."

Evidently for Velázquez it was important to stress the significance of constant thoughts about God. The scene in the background looks like a recollection of the event in the Gospel. At the same time it allowed the artist to tackle important painterly tasks. While the figures and still life are brightly illuminated against the darkness of the foreground and look tangible in their texture, the scene in the distance is uniformly lit; the contours of objects and figures are toned down. A transition to a new representational system is noticeable in the artist's work, the introduction of an illuminated background – a very important stage in the development of Baroque painting.

In the second painting, *Tavern Scene with Christ at Emmaus* (also called *The Mulatto* and cut off on the left-hand side, *ca* 1618–19; National Gallery, Dublin), secular and religious themes intermingle. The picture contains the episode from the Gospels which recounts how Christ, three days after His death, joined two of His disciples walking to Emmaus, but they failed to recognize Him. When they reached the village, Christ sat down to a meal with them: "... He took bread, and blessed it, and brake,

Engraving from the painting by Pieter Aertsen,
*Christ in the House of Martha and Mary*

and gave to them. And their eyes were opened, and they knew Him; and He vanished out of their sight." (Luke 24: 30–31). In Velázquez's painting a mulatto girl, distracted from her work, as if lost in reverie, thinking that at that moment the invisible Christ could be among them. Similar works, combining scenes from everyday life with religious and moral implications, were painted for the reception rooms of monasteries and encouraged the display of hospitality to pilgrims. In the 1610s, Velázquez was the only artist whose work embraced such a broad and fruitful spectrum in genre painting. Moreover, he became an innovator in the sphere of religious painting, bringing the treatment of subjects from the Christian canon closer to realism.

One of Velázquez's earliest religious works is *The Virgin of the Immaculate Conception* (*ca* 1617; National Gallery, London). In Spain, the doctrine of the Virgin's Immaculate Conception aroused fervent passion. In Italy the Immaculate Conception was challenged by the Dominicans, which only served to galvanize the Spanish in their defence of the principle. The struggle continued for almost half a century (the idea was only finally adopted as dogma in 1854). The promulgation of the Papal bull

in 1617, permitting mention of the Virgin's Immaculate Conception in the liturgy dedicated to her, constituted the first victory gained in the argument. The iconography of the subject was actively worked out in the sixteenth century and at the beginning of the seventeenth century. In Seville, Pacheco, who provided precise instructions to artists, took that task upon himself. The Virgin of the Immaculate Conception was associated with the vision of John the Evangelist in the Apocalypse: "And there appeared a great wonder in heaven; a woman clothed with the sun, and the moon under her feet, and upon her head a crown of twelve stars." (Revelations 12: 1). Accordingly the Virgin of the Immaculate Conception was depicted standing on a moon with stars over her head. Pacheco stated that Mary must be depicted as beautiful as possible in her appearance and her inner nature, as a maiden in her prime, 12–13 years old. In paintings, symbols referred to in the liturgy were to be introduced – a palm, roses, irises, a mirror, a lily, a portal and a throne of Solomon at the top of the stairway. This is exactly how Velázquez painted *The Virgin of the Immaculate Conception*. However, although it was assumed that the Virgin Mary was ethereal and resided in the heavens, in Velázquez's work she resembles a sculpture: immobile, three-dimensional and corporeal. The artist was indeed inspired by sculpture, since by that time a carved wooden *Immaculate Conception* by Martínez Montañés was in existence. Velázquez used the features of his fiancée, Juana de Miranda, for the countenance of the Virgin. Such personifications of religious figures began during the Renaissance period. From the end of the fifteenth century already, Spanish artists, following the example of their Netherlandish and Italian counterparts, painted saints from real people. That practice continued right up to the seventeenth century.

*KITCHEN SCENE WITH CHRIST IN THE HOUSE OF MARTHA AND MARY.* Ca 1618
Oil on canvas. 60 x 103.5 cm
National Gallery, London

*TAVERN SCENE WITH CHRIST AT EMMAUS (THE MULATTO).* Ca 1618–19
Oil on canvas. 55.8 x 118 cm
National Gallery, Dublin

Juan Martínez Montañés
*THE VIRGIN OF THE IMMACULATE CONCEPTION.* 1606–08
Church of Nuestra Señora de la Consolacíon, El Pedroso

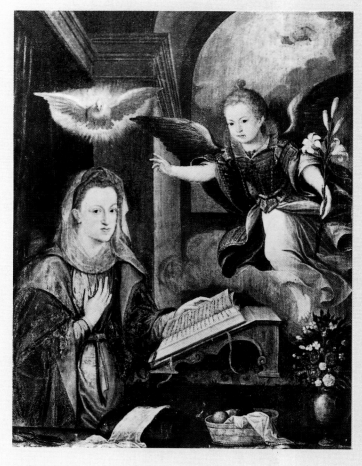

Juan Pantoja de la Cruz
*THE ANNUNCIATION*
Kunsthistorisches Museum, Vienna

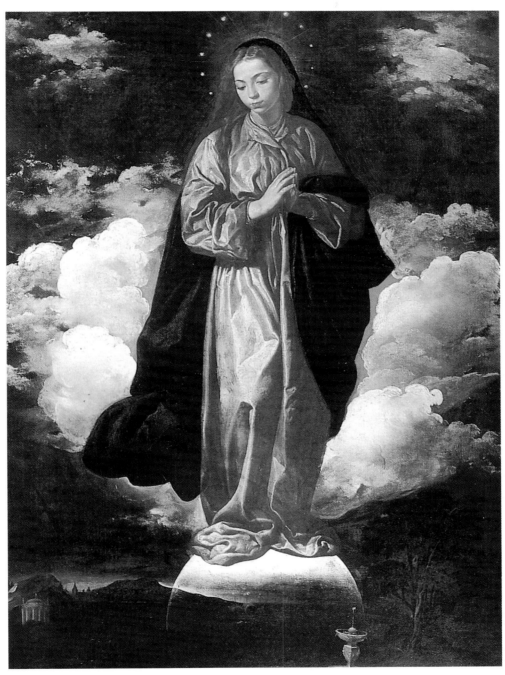

*THE VIRGIN OF THE IMMACULATE CONCEPTION.* Ca 1617
Oil on canvas. 135 x 101.6 cm
National Gallery, London

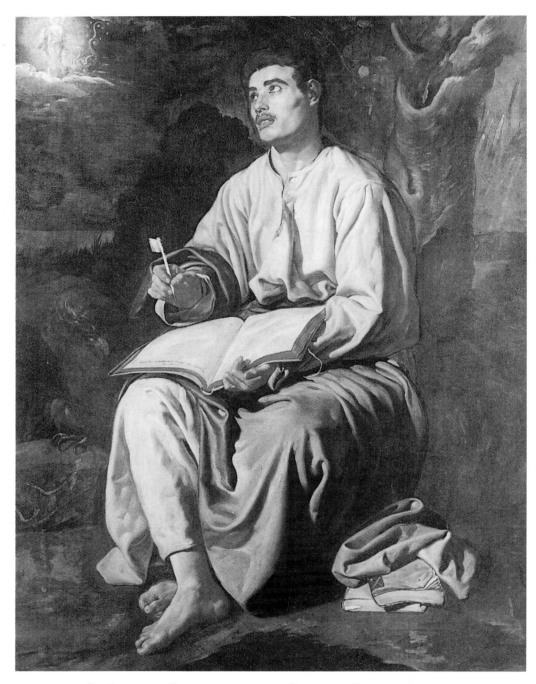

*ST JOHN THE EVANGELIST ON THE ISLAND OF PATMOS.* Ca 1617
Oil on canvas. 135.5 x 102.2 cm
National Gallery, London

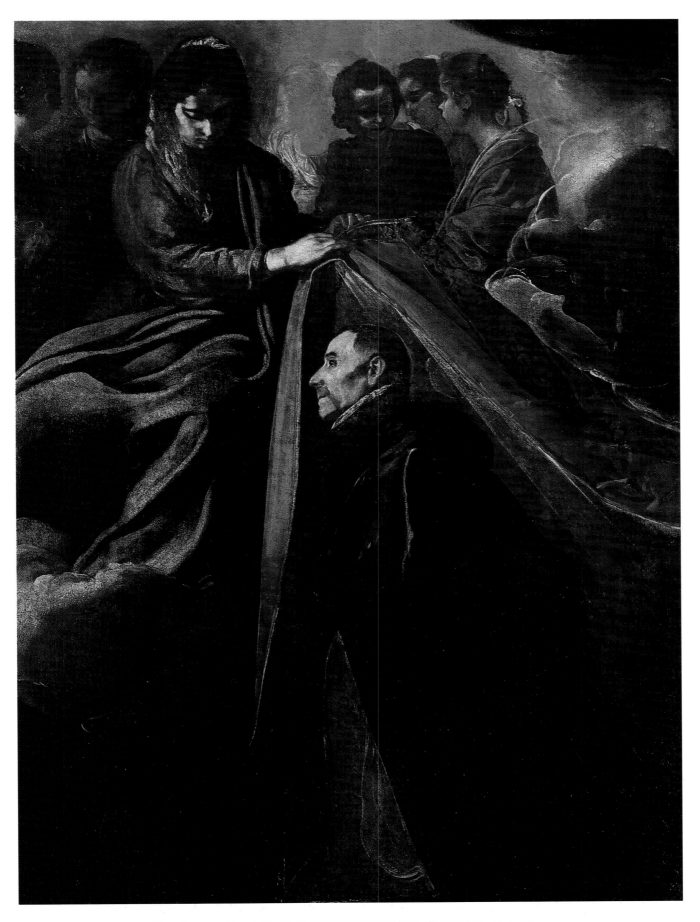

*THE INVESTITURE OF ST ILDEFONSO WITH THE CHASUBLE.* Ca 1623
Oil on canvas. 165 x 115 cm
Museo Provincial de Bellas Artes, Seville

In 1603 Pantoja de la Cruz depicted members of the royal family in *The Annunciation*. *The Nativity of Christ* and *The Nativity of the Virgin*. The companion painting to *The Immaculate Conception* is *St John the Evangelist on the Island of Patmos* (ca 1617; National Gallery, London). In the upper part of the composition is the Apostle's vision of the Virgin. It is believed that St John is a self-portrait of Velázquez.

The painting *The Investiture of St Ildefonso with the Chasuble* (ca 1623; Museo Provincial de Bellas Artes, Seville) is also associated with the theme of the Immaculate Conception. St Ildefonso, an archbishop of Toledo, who lived in the seventh century, insisted on the Virgin's Immaculate Conception in his works. According to legend, a miracle occurred one day: Mary descended from the Heavens and handed St Ildefonso a chasuble. This subject was common in fifteenth-century Spanish art, but was subsequently forgotten. The works of St Ildefonso were printed for the first time in 1556 as a result of renewed interest in the Immaculate Conception; in 1616 they were published in Madrid and then, in 1618, in Toledo. Reviving the theme of *The Investiture of St Ildefonso with the Chasuble* in his own work, Velázquez infused it with a sacramental tone, while at the same time depicting the faces of the characters in a very realistic manner.

The merging of religious and sacramental themes with real life was reflected in *The Adoration of the Magi* (1619; Prado Museum, Madrid), in which Velázquez once again depicted Juana as Mary and his newly-born daughter as the Infant Christ. The young king at Mary's feet is a self-portrait, while the figure behind him is Francisco Pacheco, his father-in-law and teacher. Although the religious works just mentioned are open-air scenes, in contrast to the *bodegones* where the action takes place inside,

the artist utilizes the same chiaroscuro style and dense texture imparting a sculptural effect to the figures.

*St Paul* (ca 1619–20; Museo de Arte de Cataluña, Barcelona) also belongs among the religious works of Velázquez's early period. At the beginning of the seventeenth century in Toledo, El Greco produced several series of *Apostolados* – depictions of the Twelve Apostles with Christ at their head – which were well known to contemporaries. Jusepe de Ribera created a similar series, possibly influenced to some extent by El Greco's art. Velázquez would probably also have been acquainted with them. However, Ribera and Velázquez belonged to the younger generation, and while El Greco's treatment of the Apostles is expressive and emotionally charged, Velázquez's is notable for its restraint and equanimity. It is curious that Velázquez depicted the Apostle Paul without a sword, a detail of paramount importance in Catholicism as it was the symbol of the Church Militant. Only once did El Greco permit himself to paint St Paul without a sword, in *The Apostles Peter and Paul* (1587–92; Hermitage, St Petersburg; 1605 variant in the Nationalmuseum, Stockholm). This omission reflected El Greco's own belief in Christian humanism. The fact that El Greco commissioned an engraving of the painting from the artist Astor reveals just how significant the work was to him. Velázquez probably shared El Greco's views since his depiction of St Paul, book in hand and bereft of sword, is not that of the militant Apostle, but of the preacher and author of the Epistles. Velázquez's view of St Paul coincided with that held by Erasmus's followers.

It is easy to notice that Velázquez, whether painting works of a secular or religious nature, always depicted the figures that populated his paintings in a portrait-like manner. An opportunity to create an actual

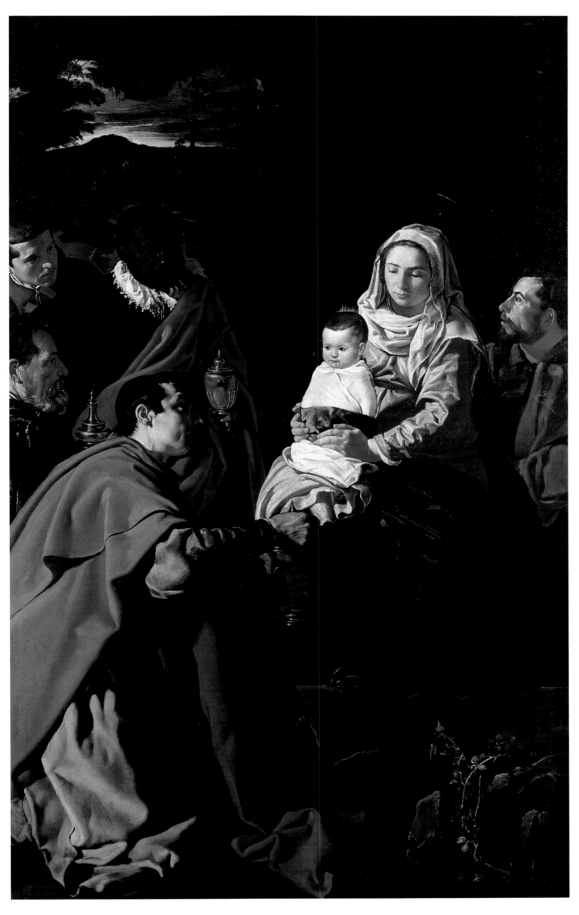

*THE ADORATION OF THE MAGI.* 1619
Oil on canvas. 203 x 125 cm
Prado Museum, Madrid

Diego de Astor
Engraving from the painting by El Greco,
*The Apostles Peter and Paul*. 1605

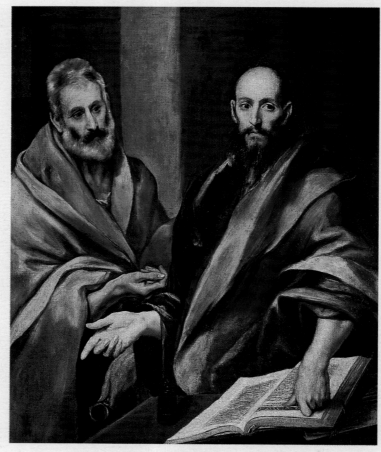

El Greco
*THE APOSTLES PETER AND PAUL*. 1587–92
The Hermitage, St Petersburg

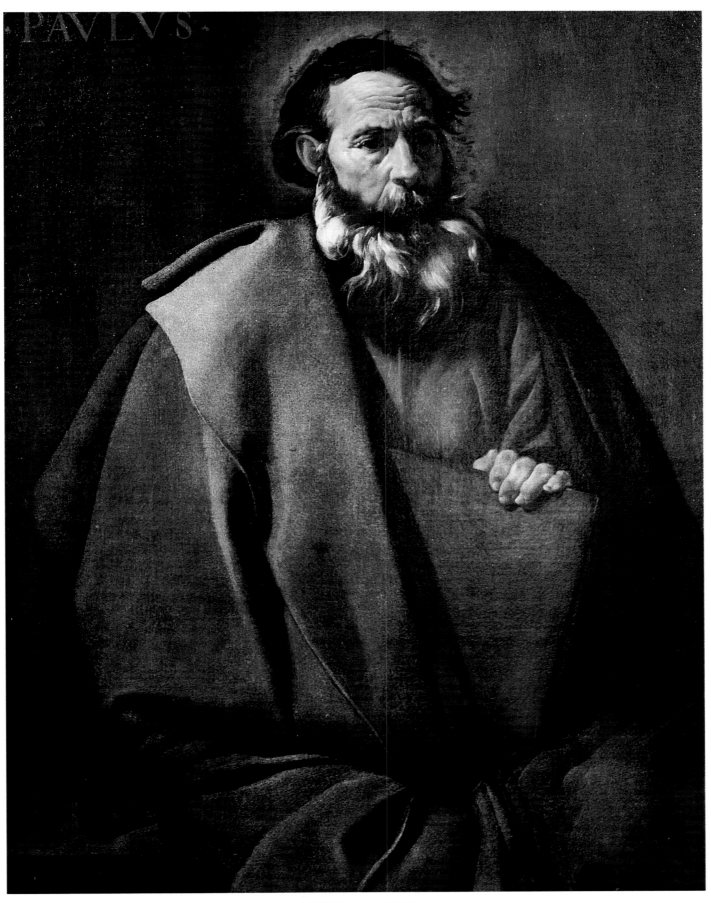

*ST PAUL.* Ca 1619–20
Oil on canvas. 98 x 78 cm
Museo de Arte de Cataluña, Barcelona

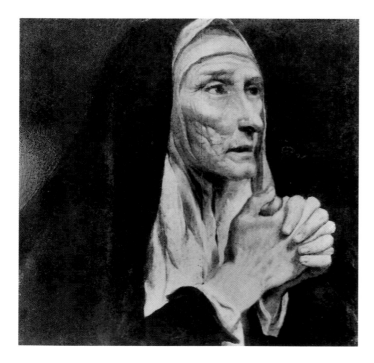

Luis Tristán
*ST MONICA* (?)
Prado Museum, Madrid

manuscripts which are now lost, wrote that Velázquez had been influenced by Luis Tristán, a pupil of El Greco in Toledo, who had been to Italy and who highly valued the art of Caravaggio.

Velázquez's achievements were so impressive that Pacheco decided to send him to Madrid with recommendations to influential people. Former members of the Seville Academy lived in the capital, and Pacheco hoped they would be able to help his talented pupil. He also hoped that Velázquez might get the opportunity to paint portraits of the King and Queen. Velázquez himself dreamed of visiting the Escorial. During this visit the artist did not succeed in painting the royal couple, but at Pacheco's request he made a portrait of Luis de Góngora (1622;

*SOR JERÓNIMA DE LA FUENTE.*
Detail

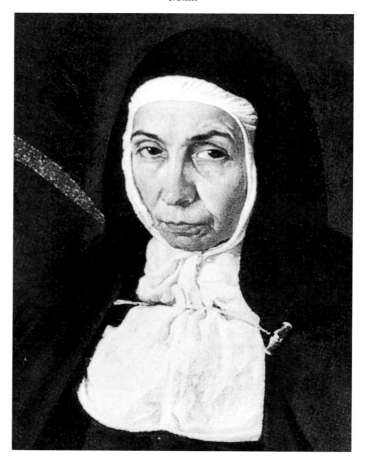

portrait in its own right arose in June 1620, when the nun Jerónima de la Fuente passed through Seville. At the time Velázquez painted her, Jerónima de la Fuente was on her way from Toledo to Manilla to establish a Franciscan convent. The painting contains a detailed inscription stating that the nun was sixty-six years old. The artist created two variants of the portrait (at the present time, one is in the Prado Museum, the second in a private collection in Madrid). It is difficult to say which particular works Velázquez based this composition on. On the one hand, the painting reflects his striving towards an accentuated monumentality, and on the other hand, the artist painstakingly renders a face furrowed with wrinkles. In this regard the portrait of Jerónima de la Fuente strikingly recalls *St Monica* by Luis Tristán (Prado Museum). It is not improbable, however, that Velázquez owned specimens of that artist's work. One of Velázquez's early biographers, Antonio Palomino, using seventeenth-century

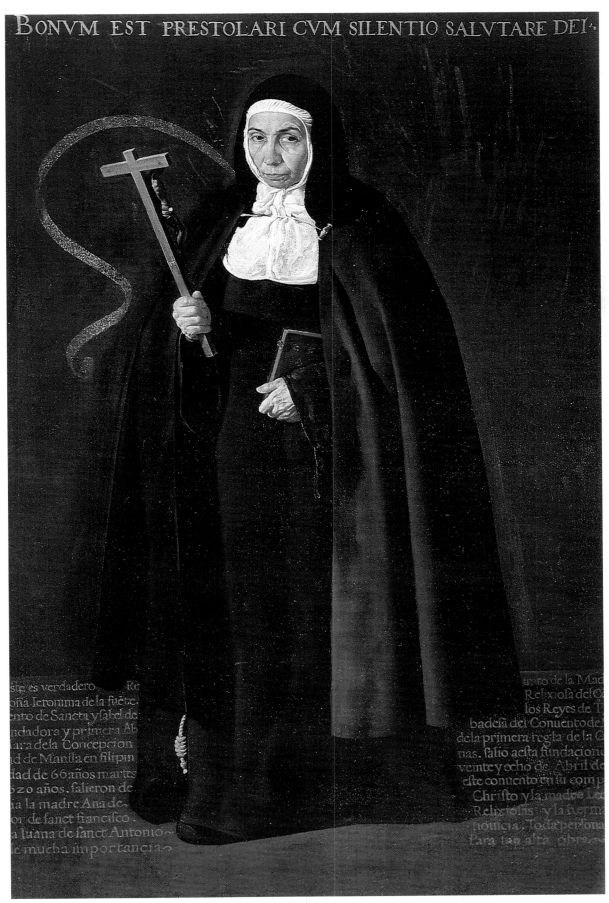

SOR *JERÓNIMA DE LA FUENTE*. 1620
Oil on canvas. 160 x 110 cm
Prado Museum, Madrid

Pedro Campaña
*THE PRESENTATION IN THE TEMPLE*
Detail: Portraits of donors
Cathedral, Seville

Museum of Fine Arts, Boston) – a famous poet and admirer of El Greco, whose epitaph he composed. The portrait of Luis de Góngora depicted an important, severe personality, endowed with particular energy like the portrait of Jerónima de la Fuente. The penetrating glance, the frown, the powerful chiaroscuro modelling of the face, create an overall impression of vigour and firmness of purpose. To some extent Velázquez followed the traditional approach, characteristic of sixteenth-century artists. In the mid-sixteenth century the Netherlandish painter,

Peter de Kempener or, as he was called in Spain, Pedro de Campaña, worked in Seville. He produced an altarpiece *The Presentation in the Temple* for the cathedral, with portraits of donors on the wings. This work must have been known to Velázquez and evidently influenced him. The powerful treatment of figures in Velázquez's early portraits may have its origin here.

It is not known how long Velázquez spent in Madrid during his first visit. In any case by January 1623 he had returned to Seville. Towards the summer, however, he received a summons from Conde-Duque de Olivares to come to Madrid to paint a portrait of the King. Olivares had close ties with Seville, as his family lands were situated in the vicinity of the city. There is evidence that in 1611 Pacheco painted his portrait. Velázquez returned to Madrid and by 30 August 1623 had completed the portrait of the monarch (which has unfortunately not survived).

Painting was much appreciated at the royal court, and Velázquez's talent was highly prized. The artist was ordered to move to Madrid with his family. On 6 October 1623 he was appointed Painter to the King (*Pintor del Rey*). With this position a new stage in his life and work began.

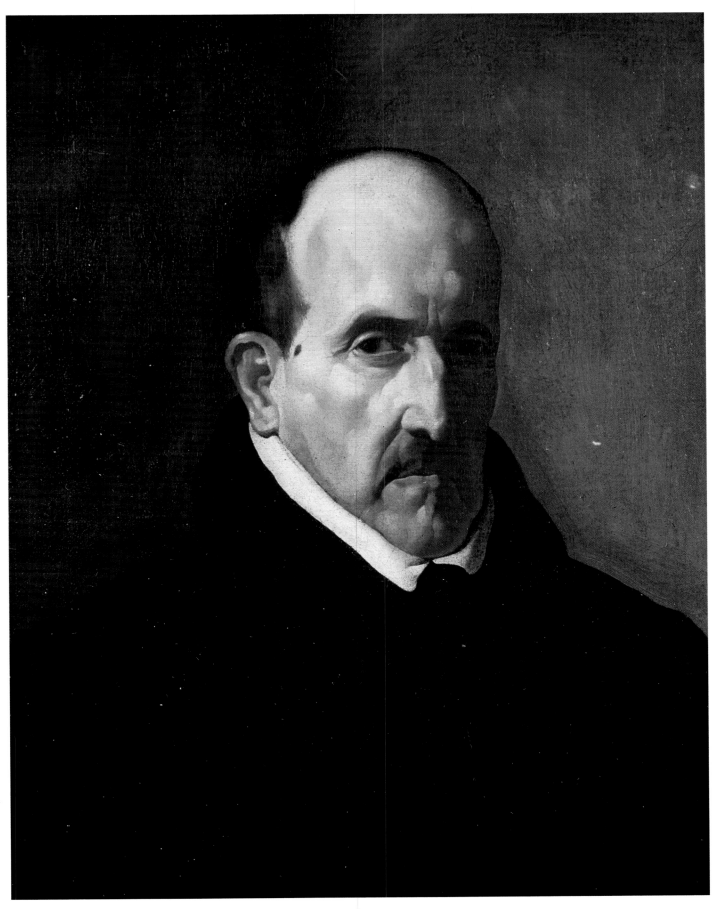

*LUIS DE GÓNGORA.* 1622
Oil on canvas. 51 x 41 cm
Museum of Fine Arts, Boston

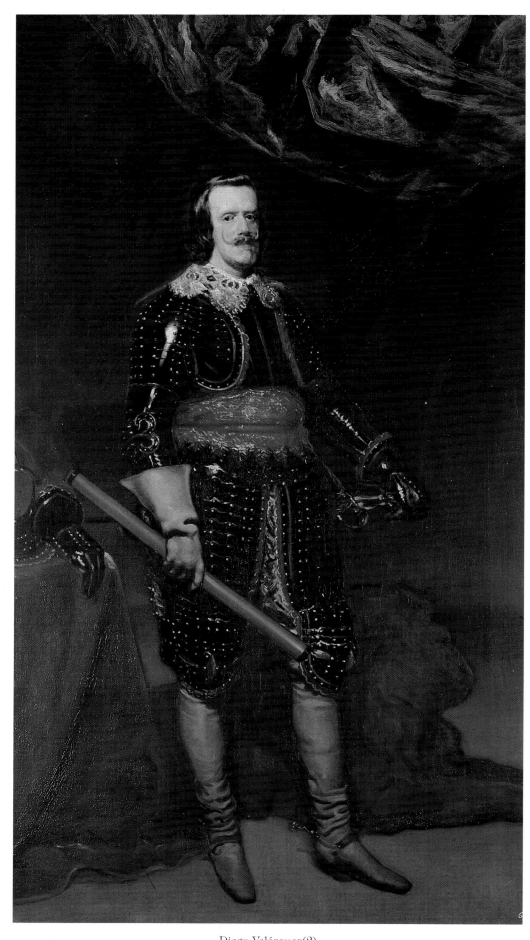

Diego Velázquez(?)
*PHILIP IV IN ARMOUR*
Oil on canvas. 231 x 131 cm
Prado Museum, Madrid

40

Madrid became the capital of Spain in 1561 when Philip II decided to transfer his court there. A small settlement around a fortress rapidly grew into a thriving city that attracted many people. The Escorial was founded not far from Madrid in 1563: a grandiose monument to the Spanish monarchy which included a palace, a monastery, a church and a mausoleum. On the outskirts of Madrid there were other residences – El Pardo and Aranjuez. The best artists from across Spain and Italy too were invited to decorate the new capital starting with the Escorial. Spanish monarchs were connoisseurs of painting: Charles I and Philip II were patrons and collectors, and the artistic treasures they amassed were concentrated at the court. The Alcázar in Madrid was the principle residence of the royal family. The palace was erected on the site where a medieval fortress had once stood. After the death of Philip II in 1598, his son Philip III, married to Margaret of Austria, ruled the country. The royal couple had five children: Anna, Maria, Philip, Carlos and Fernando. The Queen died in 1611 during childbirth, when Philip, the heir to the throne, was six years old. Four years later, in 1615, two weddings strengthening the union between France and Spain were arranged: Infanta Anna was married to the future King Louis XIII, and the ten-year-old Prince Philip to the thirteen-year-old

## MADRID
## 1623–1629

Unknown Spanish artist of the 17th century
*THE ALCÁZAR. MADRID*
Museo Municipal, Madrid

Isabel of Bourbon, daughter of Henry IV and Marie de Medici. In 1621 Philip III died and the throne passed to Philip IV. At the age of sixteen he became the ruler of one of the greatest European powers. His retainer, Conde-Duque de Olivares, taking advantage of the King's inexperience and weakness of character, practically took over the ruling of the country. Don Gaspar de Guzmán, Conde-Duque de Olivares, was born in 1587 in Rome where his father was serving as Spanish ambassador to the Holy See. Gaspar spent his childhood in Italy, first in Rome, then in Sicily and Naples, where his father acted as viceroy. In 1600 the family returned to Spain. Since Gaspar de Guzmán was only the second son, he did not expect to inherit and therefore prepared himself for a career in the Church. He was sent to study at the University of Salamanca where he received a good education. It was there, too, that he acquired a profound love for books, which he retained throughout his life. The death of his elder brother was to change Don Gaspar's fate. He became the heir to the family lands in Andalusia and, after the death of his father in 1607, assumed the title of third Conde-Duque de Olivares. Aspiring to a career at court, Olivares set his sights on Madrid. Shortly after, he married his cousin, Doña Inés de Zúñiga, one of the Austrian Queen's ladies-in-waiting. Between

1607 and 1615 Olivares constantly journeyed between Seville and Madrid, persistently attempting to obtain an appointment at court. At last, in 1615 after Prince Philip's marriage, he was appointed King's Chamberlain. Olivares was not immediately successful in securing the favour of the Prince, but with the passing of time he became indispensable to him. Shortly after

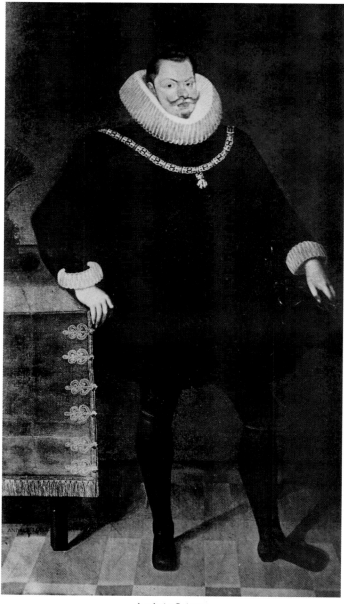

Andrés López
*PHILIP III.* 1610
Středočeska galerie v praze, Prague

Philip IV came to the throne in 1622, Olivares received an appointment as minister. He was thirty-five years old, in the prime of life and suffused with vainglorious intentions. The economy of Spain was falling deeper and deeper into decline. Olivares dreamed of restoring Spain to its former might. He wanted to mould Philip in the same manner as his predecessors, Charles I and Philip II: the former had achieved success through military victories, the latter as an energetic statesman.

That was the situation at court when Velázquez arrived at Olivares' invitation. It is difficult to imagine a sharper contrast than that between the life the artist had led in Seville, a southern port city, and that which was in store for him in the haughty atmosphere of the court, rife with intrigue, where the ceremonial, introduced under Charles I, was noted for its extreme complexity, and the rules of etiquette for their strict regimentation.

Nevertheless, there were far more opportunities for Velázquez's talent to flourish in Madrid. Among the Painters to the King (*Pintores del Rey*), traditionally appointed in Spain, one in particular was closest to the King and known as the *Pintor de Cámara*. Portraiture was accorded special significance at court and so portrait painters were usually appointed to this post. The school of royal Spanish portraitists was one of the leading schools of its kind in Europe from the mid-sixteenth century.

In the first quarter of the seventeenth century, a late Mannerist trend, with a propensity for Academism, prevailed in the artistic world in Madrid. Vicente Carducho, the author of a theoretical work, *Diálogos de la Pintura*, published in 1633, was recognized as the leader of painters in Madrid. Carducho was inspired by the masters of the Italian Renaissance. He attempted to establish an academy in Madrid,

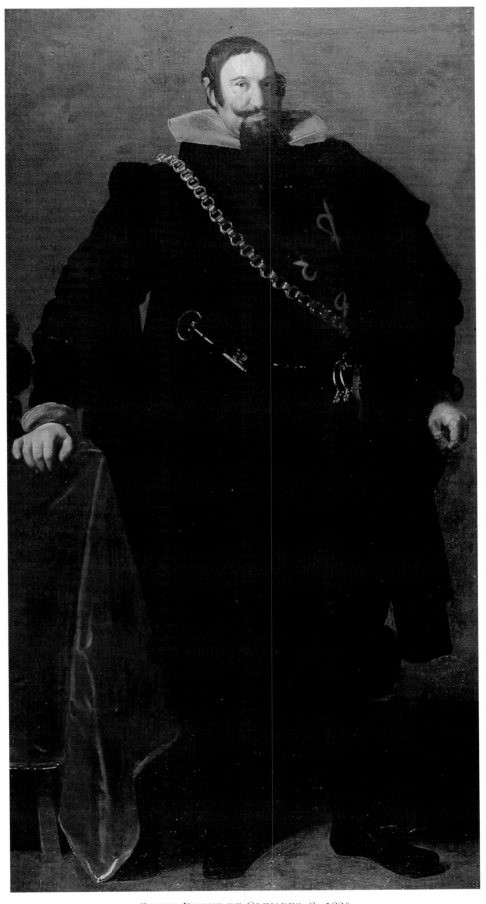

*CONDE-DUQUE DE OLIVARES.* Ca 1624
Oil on canvas. 201 x 111 cm
Museu de Arte, São Paulo

43

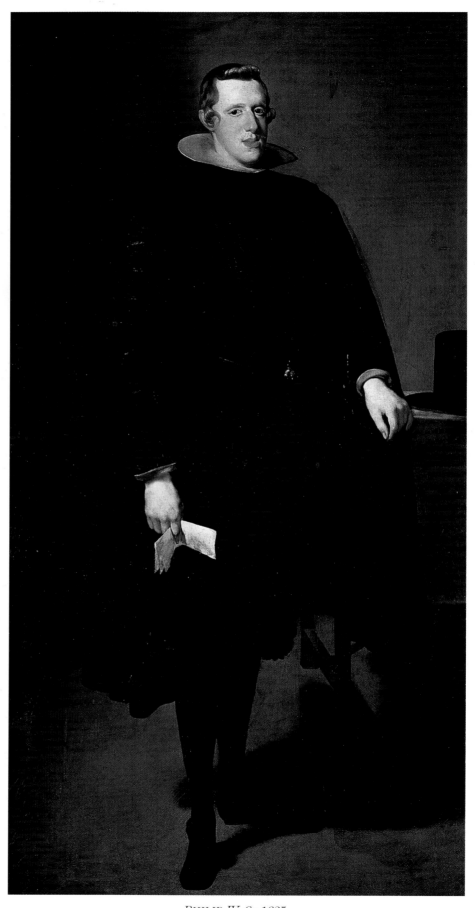

*PHILIP IV.* Ca 1625
Oil on canvas. 201 x 102 cm
Prado Museum, Madrid

but his efforts were not crowned with success. He himself was exceptionally industrious, producing numerous paintings for churches and religious houses in Madrid. Vicente Carducho was jealous and resentful about Velázquez's appointment to the court. The young Sevillian painter, creator of *bodegones*, did not correspond to Carducho's conception of the artist's high calling.

Velázquez's duties began in August 1623. At that time the artist painted a portrait of the King, made a sketch for a portrait of the Prince of Wales (later Charles I of England) who was on a visit to the Spanish court; he also painted a likeness of the Chaplain to the King Juan de Fonseca. Not one of these works has survived.

The earliest of Velázquez's portraits to have come down to the present day is one of Olivares (*ca* 1624; Museu de Arte, São Paulo). The minister is depicted here with the red Order of Calatrava, which he soon abandoned for the green-coloured Order of Alcántara (in January 1625 Olivares was awarded yet another title – Duque de San Lucaro, and henceforth was called Conde-Duque). In the portrait, the large key at Olivares' belt indicates his appointment as Chamberlain, while the bridle points to his honorific title of Chief Equerry. It is not unlikely that the work was executed at the request of Doña Antonia de Inpeñareta, who in December 1624 paid Velázquez for three portraits: of Philip IV, Olivares and her husband. Olivares' portrait is stylistically akin to the Spanish royal portraits of the 1610s, and in particular to the portrait of Philip II painted by Andrés López (1610s; Středočeska galerie v praze, Prague).

The court portraitists at the time followed the scheme for state portraits devised by Pantoja de la Cruz at the turn of the seventeenth century: the figure stands by a table draped with red velvet and gold braid; one hand rests on the table, while the other is placed on the hilt of his sword. In the 1610s, an enlargement in the dimensions of such works took place as part of a new stylistic conception in portraiture, imparting a greater sense of grandeur.

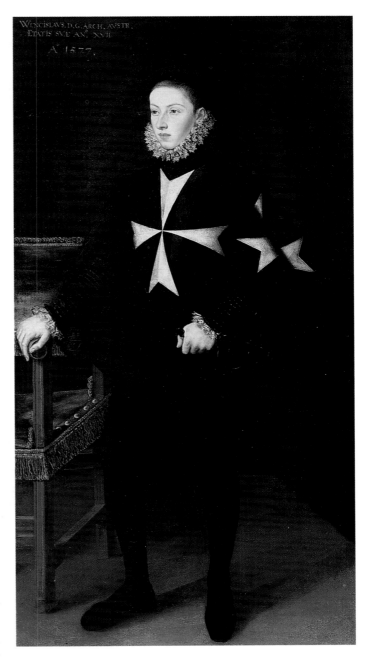

Alonso Sánchez Coello
*PORTRAIT OF THE ARCHDUKE WENCESLAUS.* 1577
Středočeska galerie v praze, Prague

In this style, figures are presented as flat, black silhouettes on the narrow space of the foreground, their collars, cuffs and large gold chains, elegantly complementing their plain attire. In the portrait of Olivares, Velázquez followed this guideline, while introducing several elements in dress which reflect changing fashion. The imparting of a three-dimensional quality enhances the sense of grandeur in the portrait. This type of formal portrait was subsequently repeated time and again in Velázquez's studio.

The works of Alonso Sánchez Coello, Philip II's favourite painter, gave Velázquez the opportunity to fully appreciate the strict refinement of Spanish court portraiture. In Coello's works, such as the portrait of the Archduke Wenceslaus (1577; Středočeska galerie v praze, Prague), we find the same use of a black silhouette, while costume is far more refined than in the portraits produced in the 1610s. Velázquez could have been inspired by Alonso Sánchez Coello's work, particularly in his first state portraits of the young Philip IV. The composition of the famous portrait of the King dressed in black (*ca* 1625; Prado Museum) differs considerably from the portrait of Olivares. Here we can see Velázquez's characteristic treatment of figure: reserved and remote, without any hint of affectation or bravura. One can only be struck at how such a young painter, who had only recently arrived from Seville and so far mainly depicted scenes from everyday life, could feel and express the quintessential spirit of the Spanish court, capturing the sense of aristocracy and dignity in his portrayal of the King. Velázquez chose a viewpoint below his subject, allowing him to create the illusion of an elongated figure, seemingly setting the monarch on a pedestal. This technique could have been borrowed from his predecessors' works, but in Velázquez's painting the pose acquires a natural elegance, and

gestures – a natural ease. In contrast to the portrait of Olivares, in which the floor is still restricted to a narrow strip, Velázquez here deepens the space, following Alonso Sánchez Coello's style, yet at the same time resolving the problem in a more daring manner. He strongly illuminates the floor, thus dissolving the line between it and the wall. Through the use of this device, the King's slender legs, in their black stockings, stand out sharply against a light background, and the impression of depth is further enhanced by the shadows falling from the figure, along with the foreshortening of the table top.

A portrait of the Infante Don Carlos (*ca* 1626; Prado Museum), a brother of Philip IV, also belongs to much the same period. Here again, we find the figure portrayed in a black costume set against a silver-grey background. In this work Velázquez, breaking with the tradition of court portraiture, glosses over to a large extent the detail of the furnishings. The gesture of the hand disdainfully dangling a glove is surprisingly natural and spontaneous. Having assimilated the best from his predecessors' court portraits, Velázquez went on to overcome the tension and constraint present in their portraits, creating as a result formal paintings unique in world art: reserved, austere, aristocratic and, at the same time, distinguished by their striking ease and naturalness.

Titian's works, a unique collection of which was assembled at the Spanish court, had a great impact on Velázquez. The Spanish King, Charles I (better known to history as the Holy Roman Emperor Charles V) was one of Titian's main clients and patrons, and the artist painted numerous portraits of the King. In 1548, in commemoration of the Emperor's victory over the Protestant armies, a tremendous work of art, *The Emperor Charles V on Horseback*,

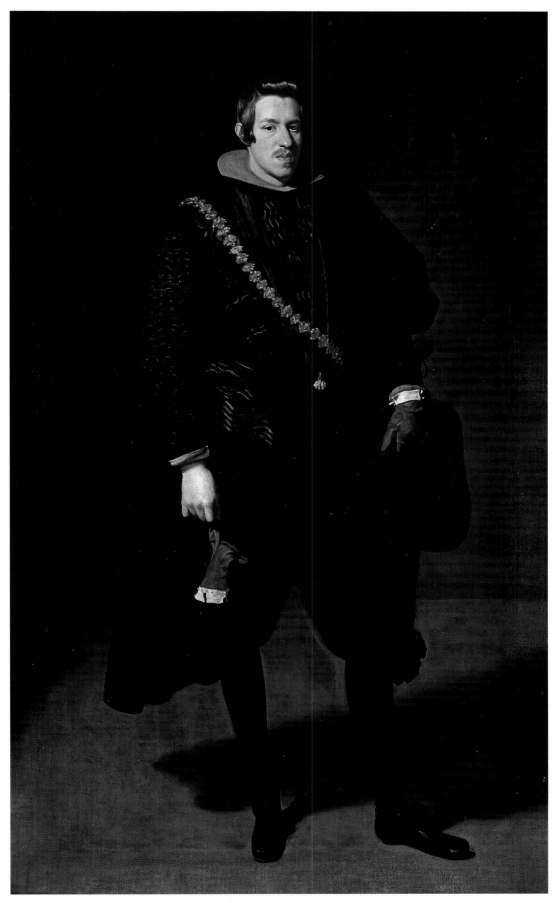

*THE INFANTE DON CARLOS DRESSED IN BLACK.* Ca 1626
Oil on canvas. 209 x 126 cm
Prado Museum, Madrid

*at Mühlberg* (Prado Museum) – the first equestrian portrait in Western European painting – was created. It is difficult to imagine a more majestic sight than the figure of a solitary horseman, in the three-metre space of the canvas. Charles V "parades" past the viewer on his horse, a long lance in hand – a motif Titian borrowed from portrayals of Roman Emperors, where it symbolized supreme power. The triumphant celebration of colours, the flash of reddish-pink hues upon the baldric, the burnished armour, the horse-cloth and the plume of the horse conjure up an impression of celebratory elation.

Soon after his arrival in Madrid Velázquez received an assignment to paint an equestrian portrait of Philip IV. Velázquez took Titian's work as a model and studied the

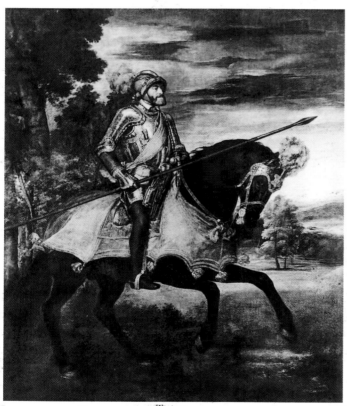

Titian
*THE EMPEROR CHARLES V ON HORSEBACK.
AT MÜHLBERG.* 1548
Prado Museum, Madrid

Venetian master's technique, which was very different from his own early style. Titian's genius shone through in his treatment of the subject-matter. Instead of a dense application of paint and elaborate working of volumes with contrasts of light and shade, Titian chose a multicoloured palette and a broad, easy brushstroke, achieving both an effect of three-dimensionality and a profusion of tones. Velázquez immediately recognized the great potential of this technique. In 1625 the portrait was completed and displayed on the façade of the Church of San Felipe on the main street of Madrid, eliciting general approval. Subsequently, the portrait was placed in the recently restored New Hall (*Salón Nuevo*) of the Alcázar, opposite Titian's painting. Among the portrait's many admirers was the famous Italian collector, Cassiano dal Pozzo, who arrived in Madrid in 1626 among Cardinal Francesco Barberini's retinue, and saw the portrait in its original setting. Unfortunately, this work has not survived.

In terms of period, the equestrian portrait is close to *Philip IV in Armour* (ca 1628; Prado Museum). The coloristic approach seen in this canvas, the tinges of colour upon the red baldric and the highlights upon the gilded armour are a testament to Velázquez's movement towards a new style, although a considerable amount of time elapsed before he finally moved away from his accustomed dense manner. While Titian's *Emperor Charles V on Horseback, at Mühlberg* served as a prototype for the equestrian portrait in a landscape, the portrait of Prince Philip (Prado Museum), painted by Titian from life at Augsburg in 1550–51, played the same role for Velázquez's depictions of people in interiors.

The heir to the Spanish throne, the future King Philip II, was depicted in one of the rooms of the palace, with a column and a

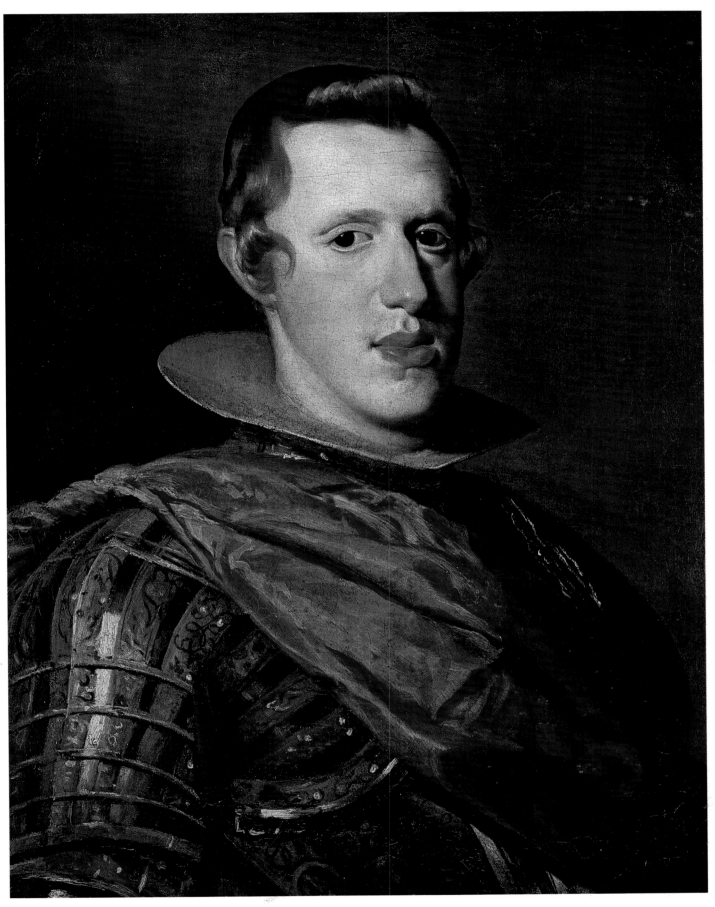

*PHILIP IV IN ARMOUR.* Ca 1628
Oil on canvas. 57 x 44 cm
Prado Museum, Madrid

*PHILIP IV.* Ca 1628
Oil on canvas. 207 x 121 cm
Ringling Museum of Art, Sarasota, Florida

50

table draped with red velvet in the background. The Prince wears armour inlaid with gold, his left hand resting on his rapier, while the right is stretched towards the helmet lying on the table. The painting is masterly in its spontaneous observation of the model. Titian did not depict all the details with great precision, but concentrated instead on the general impression of forms and colours, as is obtained at a distance. He worked up the richest hues with a broad brush, conveying the glittering of the armour with dabs of white paint. At the time, his bold style astonished the Prince. Dispatching his portrait to María, Queen of Hungary, he wrote: "The swiftness with which the painting was executed is easy to detect. If there had been time, he would have completed it." It was not the only criticism made of the Venetian master. A story has survived that Charles V's ambassador in Venice, Francisco de Vargas, one day asked Titian why he painted "with thick brushstrokes and almost negligent patches of colour, and not with light touches like the best painters of his day?" Titian answered: "Sir, I have lost hope of achieving the subtlety and perfection of the work of Michelangelo, Raphael, Correggio and Parmigianino, but if I did, I would be appraised as their imitator. The presence in me, no less than in others, of creative ambition induces me to set out along new paths, which would bring me fame, as others were made famous by the path which they followed." The words of the great Venetian proved prophetic. Indeed, his method was immediately adopted by others and constituted the basis of Baroque painting. It continued to influence the development of Western European painting right up to the Impressionist movement. However, for many of Titian's contemporaries, the artist's style appeared unacceptable, and in Spain the polemics over whether one should

Titian
*PRINCE PHILIP, LATER PHILIP II, IN ARMOUR.* 1550–51
Prado Museum, Madrid

paint "smoothly" or with "blots" like Titian raged with particular strength. Velázquez certainly had no doubts concerning the merit of Titian's works. In his portrait of Philip IV (*ca* 1628; Ringling Museum of Art, Sarasota, Florida), he employed the same techniques of composition and colour as in Titian's depiction of Prince Philip. Here, too, the King stands next to a table and a column. However, the resolution of space

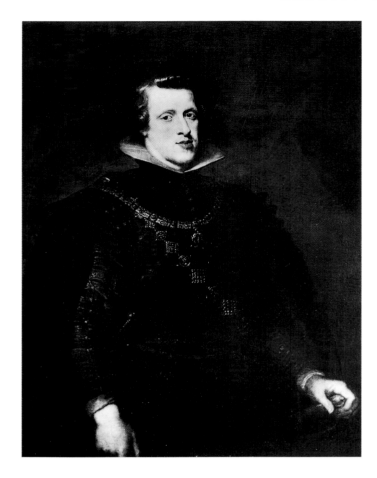

Studio of Rubens
*PHILIP IV*
The Hermitage, St Petersburg

acquires a new complexity. The column is moved to the foreground, and instead of one table, Velázquez introduces two, placed at an angle to each other. The shadows cast on the floor create an ingenious spatial effect. Velázquez fully assessed the solutions that Titian's portraits suggested for spatial problems and developed them further. The use of a richly coloured palette was also prompted by Titian – the vivid accents of red burst from the brownish-yellow range of tones, and the golden pattern of the embroidery, painted with separate strokes, is executed in the same manner used by the Venetian.

Velázquez's successes aroused the envy of other painters in Madrid. Rumours began to circulate that, portraits apart, the prospering Sevillian was bereft of talent. In order to put an end to such spiteful criticism, a competition was held between Velázquez, Vicente Carducho, Eugenio Caxés and Angelo Nardi. A historical theme – *The Expulsion of the Moriscos* – was set. The competition took place in 1627. Giovanni Battista Crescenzi and Juan Bautista del Maino acted as judges. Both unanimously awarded first place to Velázquez (His *Expulsion of the Moriscos* perished, together with many other works of art, during the fire that devastated the Madrid Alcázar in 1734.)

In the summer of 1628, one of the most important events in Velázquez's life took place – Peter Paul Rubens, arrived in Madrid on a diplomatic visit. While Velázquez was only at the beginning of his artistic career, Rubens, already over fifty, was at the zenith of his fame. The celebrated Flemish artist spent nine months in Spain; he painted a great deal, made copies of all Titian's works (several of the Venetian master's paintings, which perished in fires, are known today only through Rubens' copies). Moreover, the regent of the Netherlands, the Infanta Isabel Clara Eugenia, who was Philip IV's niece, commissioned Rubens to make portraits of all the members of the Spanish royal family. Velázquez constantly accompanied his Flemish colleague with whom he became very friendly. (Their subsequent correspondence has unfortunately not survived.) The artists visited the Escorial together. According to Pacheco, Rubens painted five portraits of Philip IV at the time, including an equestrian one, as well as portraits of the Queen and all her children. To this day all the works remain unidentified, but there exists a series of works, dating back to these originals, created by Rubens' studio. The portraits of Philip IV and Isabel of Bourbon in the Hermitage pertain to this series. A comparison of those portraits with those

by Velázquez shows how differently the Flemish and Spanish masters worked at a model. Velázquez, just like the court painters who preceded him, portrayed his sitters without striving towards idealization. In the portrait of Philip IV he emphasized the lower jaw, strongly jutting forward, and the thrusting lip, characteristic of the Habsburgs. In Rubens' work, on the contrary, the King's appearance has evidently been embellished to make him more handsome.

Velázquez probably began to paint *Bacchus and His Companions* (ca 1628; Prado Museum) when Rubens was at the court. It is curious that after his arrival in Madrid Velázquez never depicted *bodegones*. From Seville, he brought the painting *The Water Seller of Seville* – which was highly rated and later became part of the King's collection – presenting it to Juan de Fonseca as a gift. But it is not known whether at some point the artist turned once more to genre painting. Velázquez seems likely to have painted *Bacchus and His Companions* or, as it is otherwise known, *The Drinkers*, by order of the King – a document exists suggesting the artist received payment for it in July 1629. Depictions of the ancient god of wine and revelry were popular in the seventeenth century: they occurred in numerous paintings and engravings. Besides, this mythical figure evoked associations with contemporary people. Caravaggio produced a self-portrait in the guise of Bacchus (1590–95; Galleria degli Uffizi, Florence). In *The Drunken Silenus* (Museo e Gallerie Nazionali di Capodimonte, Naples), painted in 1626 and repeated as an engraving in 1628, Ribera depicted the constant companion of Bacchus, imbuing a satirical character to the figure. Velázquez also treated the ancient god with humour. He presented him as a contemporary, surrounded by contemporary followers of the

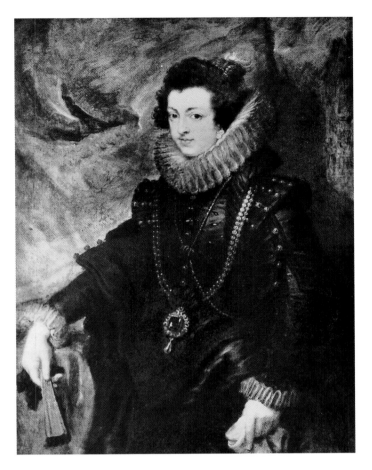

Studio of Rubens
*QUEEN ISABEL OF BOURBON*
The Hermitage, St Petersburg

Bacchus cult. Perhaps the artist depicted a rite of initiation into a society of revellers – such fraternities did exist in Spain. It is also quite possible that this is a scene from some play.

The main protagonist of the painting is a naked youth, crowned with vine leaves. Beside him is a naked satyr. In front, kneeling, are members of the group accorded the honour of crowning the god. All the figures are very expressive, but the faces of people on the right are especially picturesque – aged picaroons, classless vagabonds and people of the street who had attracted Velázquez from an early age. The introduction of a landscape is a novel feature of this work. The background is lit up with a bluish light – the device

Jusepe de Ribera
*THE DRUNKEN SILENUS.* 1626
Museo e Gallerie Nazionali di Capodimonte, Naples

Jusepe de Ribera
*THE DRUNKEN SILENUS.* 1628.
Engraving

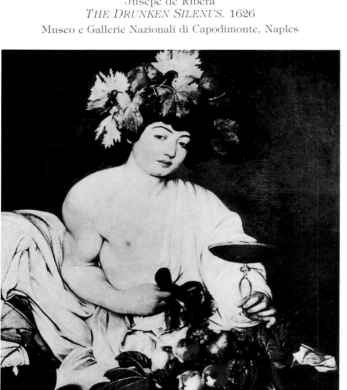

Michelangelo da Caravaggio
*SELF-PORTRAIT IN THE GUISE OF BACCHUS.* 1590–95
Galleria degli Uffizi, Florence

which led to a break with Caravaggio's Tenebrism. But the painting remains heavily impastoed, with dark shadows. The figures have clearly been painted indoors and transferred into the landscape, without regard for those changes which take place under natural conditions.

In the company of Rubens, Velázquez no doubt often heard about Italy. Plans for a joint trip there by the two artists seem probable, since the Fleming intended to return home via Italy. In the event, however, Rubens had to leave for London in April 1629, while Velázquez only received funding for his journey in June.

*BACCHUS AND HIS COMPANIONS (THE DRINKERS). Ca 1628*
Oil on canvas. 165 x 225 cm
Prado Museum, Madrid

*THE INFANTA MARÍA, QUEEN OF HUNGARY.* 1630

Oil on canvas. 58 x 44 cm
Prado Museum, Madrid

Velázquez, together with the Marquis Ambrogio Spinola (who would later become the hero of the renowned painting, *The Surrender of Breda*), sailed on 10 August 1629 from Barcelona to Genoa, arriving on 23 August. Spinola headed for Milan and Velázquez apparently accompanied him there before going on to Venice. The artist was travelling as an agent for the Spanish King and possessed both letters of recommendation and solid financial backing. In Venice, Velázquez was received by the Spanish ambassador Cristóbal Banfente y Benavides. The artist drew many sketches, the works of Tintoretto being of particular interest to him. From Venice he headed for Ferrara. There, the governor Cardinal Giulio Sacchetti met him. After a journey through Loreto and Bologna, the artist stopped in Rome where Cardinal Francesco Barberini, who had been in Madrid in 1626 and was already acquainted with Velázquez, awaited him. A nephew of Pope Urban VIII, Cardinal Barberini lodged the painter in the Vatican and provided him with the opportunity to copy the works of Michelangelo and Raphael which were kept there. Moreover, in April 1630, the Spanish Ambassador to the Vatican, Conde de Monterrey (the husband of Conde-Duque de Olivares' sister), requested the Grand Duke of Tuscany to give Velázquez the privilege of visiting the Villa Medici, famous for its classical

## THE FIRST ITALIAN JOURNEY
## 1629–1631

View of the Grotto-Loggia
in the Villa Medici Gardens, Rome.
Photograph

sculptures. Such an honour was accorded only to a select few. In May, Velázquez moved to the villa and stayed there for two months. Italy, with its ancient monuments, superb Renaissance art, and, finally, contemporary painting, revealed itself to Velázquez in all its splendour. Rome was the centre of artistic life in Europe; artists from France, Holland and Flanders congregated there. In Rome the Tenebrists, Caravaggio's followers, could be found; the masters of the new decorative Baroque style – Pietro da Cortona and Gianlorenzo Bernini – launched their careers also in Rome; the great French landscape painters Poussin and Lorrain lived there too. Velázquez was interested in works of art for more than stylistic and personal reasons, since he had also been commissioned to acquire the best works he could find for the Spanish royal collection. The memories and impressions gained from this journey were apparent for a long time in Velázquez's activities as one of the King's principal advisers on the decoration of the residences in and around Madrid. The journey to Italy inspired Velázquez artistically, although the history of the paintings which he produced during this period remains little known. Pacheco refers to a self-portrait Velázquez painted in Italy, but that work has either not been preserved or has not been identified. It is also thought that during his first Italian journey

Velázquez created landscape paintings of the Villa Medici. At present, however, the extant Medici paintings are thought to belong to his second Italian journey. Only two works were undoubtedly executed in Rome during this sojourn: *Apollo in the Forge of Vulcan* and *Joseph's Blood-stained Coat Brought to Jacob*. The former (1630; Prado Museum) is a continuation of a series of works Velázquez began in Spain with *Bacchus*. The artist again turned to a subject from classical mythology, transforming the scene into a sort of theatrical performance with characters close to contemporary life. Apollo, in the guise of a handsome youth, appears to Vulcan in order to announce the infidelity of his wife, Venus. The action is distinctly modernized, the setting recalls an ordinary smithy, and the figures are portrayed with a tinge of humour. The artistic conception reflects the painter's new achievements. Velázquez depicts nude torsos superbly, emphasizing the contrast between the muscular bodies of the blacksmiths and the effeminate body of Apollo. The classical reliefs, which he was able to study in Rome, evidently influenced him. At the same time, the psychological aspect also interested the artist: the painting marvellously depicts people's reactions on hearing startling, perturbing news. The articulation of space was no less important to Velázquez. While in earlier works, the artist tended to group people fairly tightly in the foreground, he now distributed figures freely around the room; the spatial planes are differentiated by perspective foreshortening and with the help of the complicated interaction of light, which emanates from several sources, including the furnace in the background. In this work we can see the emergence of Velázquez's own unique style, which would earn him his greatest success in the rendition of space. *Joseph's Blood-stained Coat Brought to Jacob* (1630; Escorial) is a religious

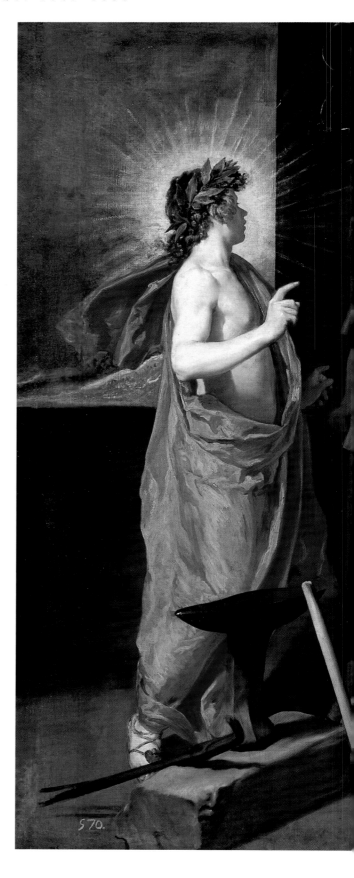

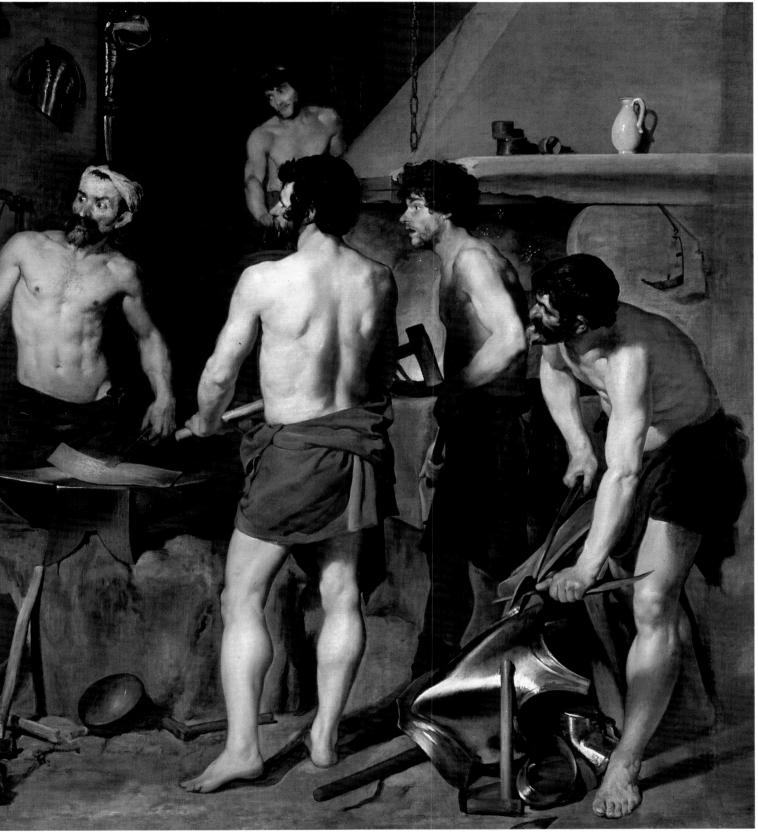

*APOLLO IN THE FORGE OF VULCAN.* 1630

Oil on canvas. 223 x 290 cm
Prado Museum, Madrid

painting in which an Old Testament episode is used. The painting recounts how Jacob's sons, jealous of their father's favouritism towards their younger brother, Joseph, sold him into slavery, and brought his clothes to Jacob, stained with blood, informing their father that Joseph had been killed. Old Testament subjects were rarely tackled by Spanish painters. They recalled the Judaic roots of Christianity, and on account of this, subjects from the New Testament were preferred on the Iberian Peninsula. The story of Jacob was an exception. The medieval author, Isidor of Seville, drew an analogy between Jacob with his twelve sons and Christ and his Apostles and imbued the episodes of the Old Testament story with symbolic meaning. It is difficult to say precisely why Velázquez turned to this particular incident in Jacob's life; it is possible that *Joseph's Blood-stained Coat Brought to Jacob* contained a meaning that is now hidden from us. At present, then, we can only judge the artistic side of the work. The same faces that appeared in *Apollo in the Forge of Vulcan* are present once again, leading one to assume that they are probably people from Velázquez's milieu. The emphasis on the perspective of the interior is of particular interest: the receding tiles of the floor lead the viewer's gaze to the background. Tintoretto used a similar device in his art. Bearing in mind that Velázquez made sketches of Tintoretto's works while in Venice, and the similarities already mentioned, it becomes clear that another Venetian master had a considerable influence on the Spanish painter. Velázquez even borrowed the motif of the barking dog in the foreground from the same source. Undoubtedly, it was Venetian painting that inspired the artist to introduce a landscape into the background, and daylight lighting, in this instance streaming in through the door in the depth of the picture. At the same time

the treatment of naked muscular bodies on the left is an eloquent testament to Velázquez's Roman lessons. *Apollo in the Forge of Vulcan* and *Joseph's Blood-stained Coat Brought to Jacob* are testimony to Velázquez's extraordinary ability to innovate and his continually new discoveries.

The exact date of the artist's departure from Rome is not known. Information exists that from there he went to Naples where he painted a portrait of the Infanta María, who was in the city on her way to marry the King of Hungary. María's stay lasted from 8 August to 18 December 1630, during which time the painting was completed. It is quite possible that this is the portrait which is today in the Prado Museum. Of all the works painted by Velázquez while in Italy, this one stands out for being freer and more soft in style. In Naples Velázquez would have met the Duke of Alcalá, the Sevillian collector and patron of the arts, who had served as ambassador in Rome for a long time and held the post of Spanish Viceroy in Naples from July 1629 to May 1631. In Naples the artist also became acquainted with Jusepe de Ribera, who had been famous in Spain since Velázquez's youth. In 1613 Ribera had become a member of the Academy of Saint Luke in Rome and in 1626 he was also admitted to the Order of Christ for his services to painting. He was eight years older than Velázquez and at the time of their meeting was a recognized master, highly esteemed by members of the royal family. Ribera did not want to return to Spain, however, as he believed that foreign artists were considered more highly in his homeland than his fellow countrymen. Nevertheless, Ribera was deeply respected in Spain and Velázquez made every effort to ensure that as many of the artist's works as possible ended up there. After Naples, Velázquez returned to Madrid and at the start of 1631 resumed his duties at court.

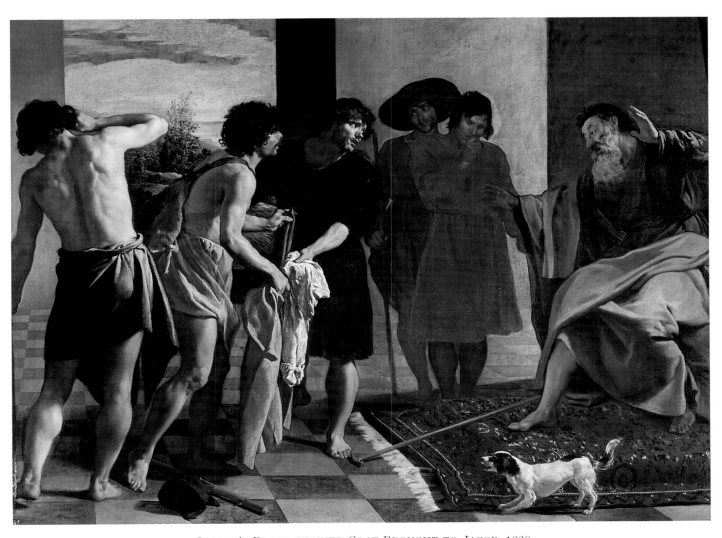

*JOSEPH'S BLOOD-STAINED COAT BROUGHT TO JACOB.* 1630
Oil on canvas. 223 x 250 cm
The Escorial

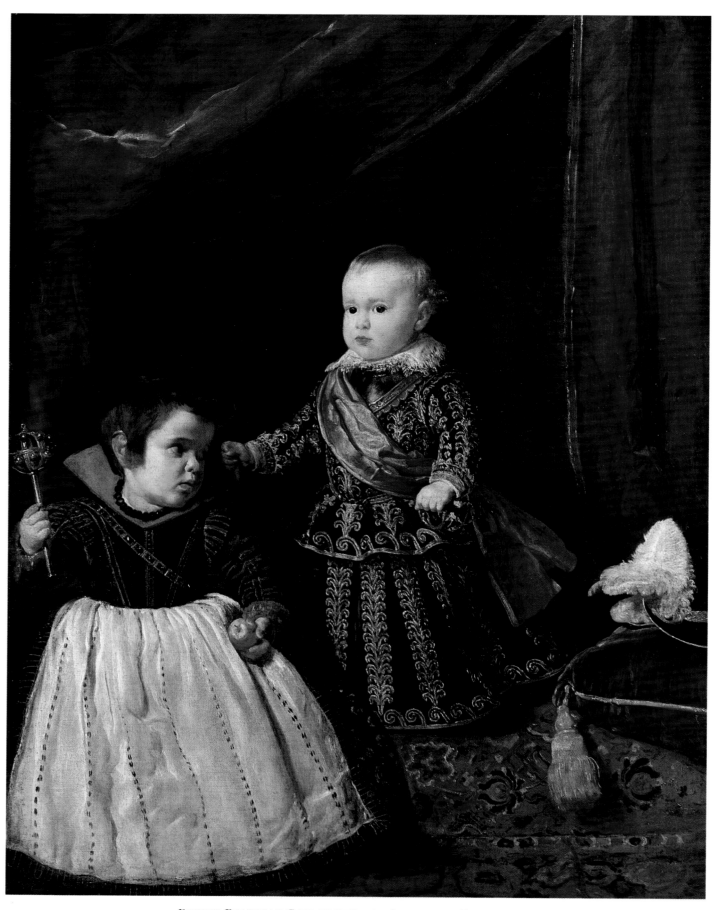

*PRINCE BALTASAR CARLOS WITH AN ATTENDANT DWARF.* 1631

Oil on canvas. 136 x 104 cm
Museum of Fine Arts, Boston

During Velázquez's absence from Madrid Philip IV did not permit any other artist to paint his portrait. On 17 October 1629 a joyful event occurred at court: the Queen gave birth to a long awaited heir to the throne, Prince Baltasar Carlos (until then the Queen had only given birth to girls, who died in infancy). Although court artists generally depicted the royal children from infancy, the King did not allow any one to paint his heir before Velázquez's return. The artist set to work immediately upon arrival. By March 1631 he had painted a portrait of Baltasar Carlos with an attendant dwarf (Museum of Fine Arts, Boston). The work bears an inscription stating that the Prince was then one year and four months old. Little Baltasar Carlos, in a smart dress decorated with a brocade design, with a commander's baton, sword and red baldric, is depicted at play with the dwarf. This work was the first in a series of charming child images created by Velázquez. The children in the portraits of the royal family by his predecessors – Juan Pantoja de la Cruz and Bartolomé González – look motionless and stiff in comparison with Baltasar Carlos. Velázquez captured the child's facial expression and gesture very accurately. The liveliness of the scene is communicated through the use of two different planes in the composition – a new device, which appeared after the artist's

## RETURN TO MADRID. THE BUEN RETIRO PALACE 1630–1635

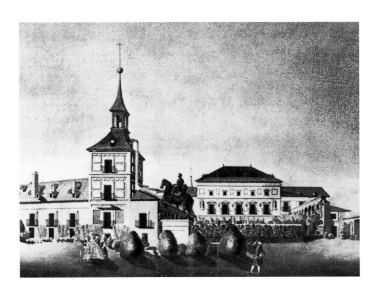

Domingo de Aguirre
*THE BUEN RETIRO PALACE*
Biblioteca National, Madrid

Italian journey when he mastered the means of conveying space. The smart carmine colours of the curtains, carpets and velvet cushion are combined with the silver and gold embroidery of the Prince's attire and the dwarf's white apron to create a festive and colourful palette, which also clearly reflects the influence of Italy. In the following year Velázquez produced another painting of Prince Baltasar Carlos (*ca* 1632; Wallace Collection, London), just as charming as the first, but in a more refined and bolder style: the dark background is painted in a brownish-red colour, and the clothes in silvery-grey hues, upon which the lilac baldric stands out. The application of paints is of particular interest: in this work, it becomes less dense, the brushstrokes are light and translucent and the highlights are just hinted at in white. The relationship of light and colour as seen from a distance forms the basis of such painting. In the nineteenth century this same method was used by the Impressionists. In this regard the portrait of Philip IV, dating from 1631–32, known as *"The Silver Philip"* (National Gallery, London), is especially striking. A long absence permitted Velázquez to see the King in a new light. Philip IV had changed: he was older now and his moustache and a new hairstyle gave him a more dandified appearance; a lively look betrayed a love of women and entertainment.

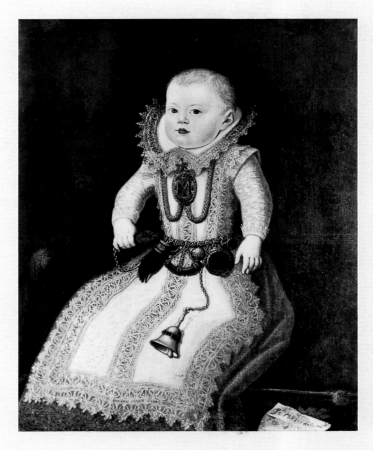

Juan Pantoja de la Cruz
*THE INFANTA MARÍA.* 1607
Kunsthistorisches Museum, Vienna

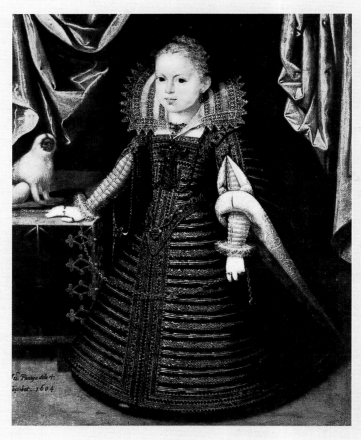

Juan Pantoja de la Cruz
*THE INFANTA ANNA OF AUSTRIA.* 1604
Kunsthistorisches Museum, Vienna

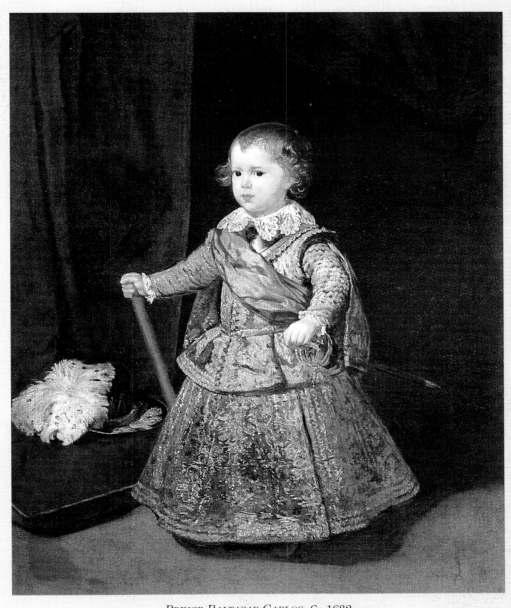

*PRINCE BALTASAR CARLOS.* Ca 1632
Oil on canvas. 118 x 95.5 cm
The Wallace Collection, London

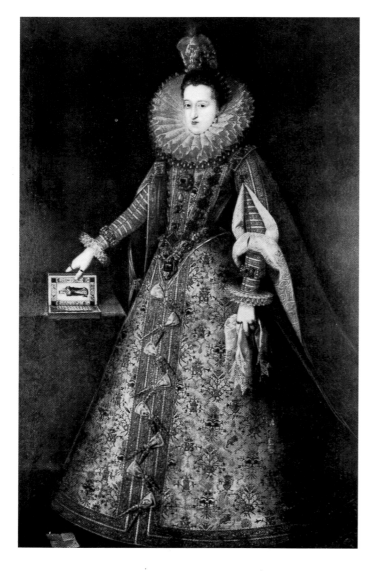

Juan Pantoja de la Cruz
*THE INFANTA MARGARITA OF AUSTRIA.* 1604
Buckingham Palace, London

On the whole the portrait represented a continuation of the old tradition. It retains the compositional scheme of a formal depiction, with the King standing in one of the palace halls, next to a table, in the traditional solemn and official posture. Of particular note is the deepening of space and the appearance of a magnificent curtain imbuing the work with a decorative effect in the spirit of the Baroque (we can clearly see here the influence of Rubens, who was renowned for his royal portraits against a background of fine drapery). Striking changes in costume have occurred in keeping with the shifts of fashion. The rich pattern on the King's clothes is similar in style to those in portraits from the turn of the seventeenth century; but whereas at that time the painstaking depiction of details was a distinguishing feature, here the stream of light and coloured patches merge to create a complete impression. The dynamism of changing brushstrokes surpasses everything produced by Titian and other Venetian painters. Velázquez acquired new qualities without shedding his previous ones: despite the use of separate brushstrokes, the inner structure of objects and bodies depicted in his canvases retains its integrity. Having developed a wonderful feel for volume during his Tenebrist period, Velázquez did not lose it in moving on to address problems of colour and light.

In the religious works Velázquez produced shortly after his return from Italy, echoes of Tenebrism are still present. However, his interest no longer centred solely on the communication of the three dimensions which preoccupied him in his early period; he strove instead to explore the drama of the subject through the use of chiaroscuro. *Christ and the Christian Soul* (1631–32; National Gallery, London) is a painting with a mystical theme. The Christian soul is depicted in the guise of a child, accompanied by a guardian angel. A light penetrating the heart of the child emanates from the suffering Christ, tied to a column, after his flagellation. The light can be seen as the justification arising from the sacrifice made by the Saviour for the sake of mankind. In the treatment of this scene, which depicts both martyrdom and enlightenment, Velázquez used a composition encountered in contemporary Italian art, in which the figures were set in the dark space of the foreground, their poses dictated by the painting's horizontal format.

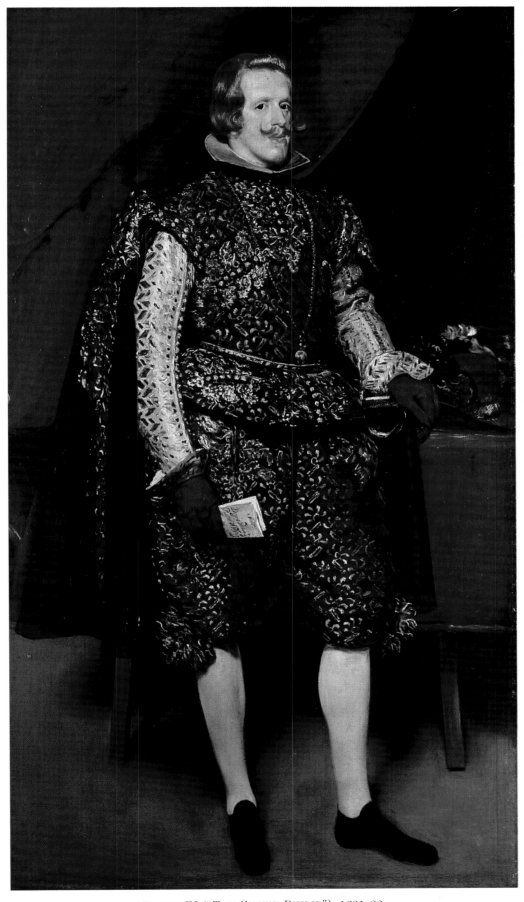

*PHILIP IV ("THE SILVER PHILIP").* 1631–32
Oil on canvas. 199.5 x 113 cm
National Gallery, London

The large, impressive *Christ on the Cross* (1631–32; Prado Museum) was painted in the Tenebrist style. In his book *Arte de la Pintura*, Pacheco devoted many pages to the proper depiction of Crucifixion: the lone figure of Christ was to be placed against a dark background. Pacheco particularly insisted that the body should be pierced with four nails. Francisco de Zurbarán followed Pacheco's guidelines when he painted his version of *Christ on the Cross* for the monastery of San Pablo El Real in Seville in 1627 (now in the Art Institute of Chicago). Zurbarán's work somewhat surpassed Pacheco's own painting in the expressiveness of the figure of Christ. It is difficult to say whether Velázquez was familiar with Zurbarán's work, but his composition is similar in austerity and restraint. The refinement of the painting is apparent in the depiction of the countenance of Christ, half-covered with falling locks of hair. The naked body is magnificently painted, with a skilfulness Velázquez honed in Italy. Aside from the commissions for his own works of art, Velázquez was also responsible for the decoration of various palaces. He brought paintings from Italy for the royal residences, and was involved in the refurbishment of the halls of the Alcázar. In 1633 Velázquez was given the task, together with Vicente Carducho, of examining all the royal portraits and removing those that did not display the requisite artistic merit and degree of likeness.

At the start of the 1630s, Juan Bautista Martínez del Mazo joined Velázquez's studio as an assistant. In 1633 he became betrothed to Velázquez's fifteen-year-old daughter, Francisca, and in 1634 Velázquez passed on his court office of Gentleman Usher to his son-in-law. In the first half of the 1630s, the artist's main concerns revolved around the Buen Retiro Palace. In 1630 the expansion of the royal apartments at the San Jerónimo Monastery, in the environs of Madrid, began. Olivares decided to build a palace devoted to entertainment on this site, which he regarded as his personal gift to the King. Intensive building activity took place throughout 1632 and 1633, and in December 1633 the Buen Retiro Palace was officially inaugurated, although subsequent improvements continued over a long period of time. The palace was conceived as a suburban villa, and although the façades were striking in their modesty, this was more than compensated by the wealth of decoration within. The park, with its lawns, unique trees, fountains and lake, occupied a vast area. Many chapels were erected there, but the main attention was focused on the facilities for theatrical performances, ball games, bull-fights and equestrian sports (the Buen Retiro had a special riding school).

One of the earliest works Velázquez created for the palace seems to have been *St Antony Abbot and St Paul the Hermit* (Prado Museum), which in the spring of 1633 was placed in the Chapel of St Paul. The work was dedicated to anchorites of the early Middle Ages. Velázquez depicted all the episodes in St Antony's journey. It is quite possible that he studied sixteenth-century Netherlandish paintings with their panoramic landscapes and combination of various narrative episodes. Employing a method similar to Poussin and Lorrain, Velázquez placed small figures in a vast space, imbuing the scene with a sense of airiness and daylight; he painted the tree and rock in the foreground in detail, gradually blurring the outlines of the landscape as they become more distant. The contours of the mountains call to mind the Guadarrama, and there is a strong argument that Velázquez painted the landscape from life. The painting's background is light and the paints are applied in thin layers so that the texture

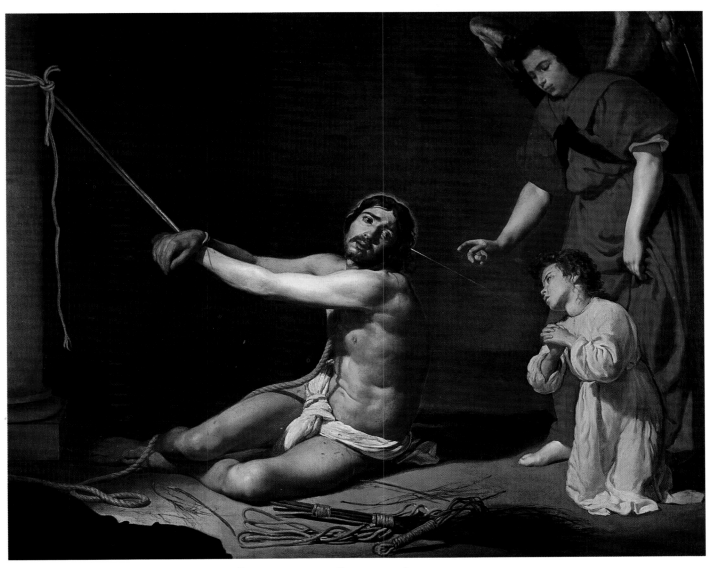

*CHRIST AND THE CHRISTIAN SOUL.* 1631–32
Oil on canvas. 165 x 206 cm
National Gallery, London

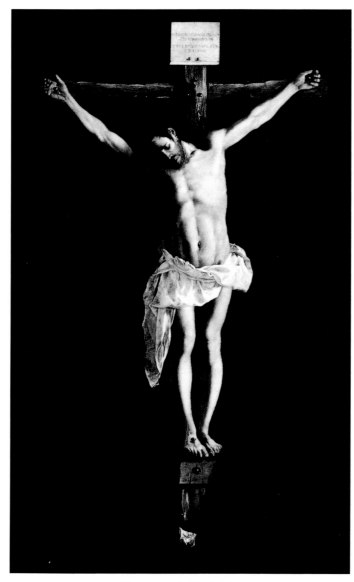

Francisco de Zurbarán
*CHRIST ON THE CROSS.* 1627
Art Institute of Chicago

of the canvas is visible. The lessons of the Venetians clearly went in, as Velázquez assimilated their painterly technique and their use of light.

The Hall of the Kingdoms (*Salón de Reinos*) was the grandest in the Buen Retiro Palace. As it was used for official ceremonies, the hall's decoration extolled the invincibility of Spanish arms. There were paintings dedicated to Spanish victories in the Thirty Years War (1618–48), equestrian portraits of Philip IV's parents – Philip III and Margaret of Austria, of the King himself and his wife, Isabel of Bourbon, as well as of the heir to the throne, Prince Baltasar Carlos. Placed between the paintings celebrating the twelve victories of the Spanish army, were depictions of the feats of Hercules, whom legend associated with the founding of the royal dynasty. Coats of arms of all the lesser kingdoms making up Spain were included in the decoration (hence the name of the hall). Many artists participated in the design of the interiors, and in the mid-1630s the palace became a centre of artistic life in Madrid. In 1634 Francisco de Zurbarán arrived there from Seville. He was commissioned to paint the twelve pictures of Hercules' feats, but completed only ten, along with two battle scenes (one of which has been lost). Vicente Carducho, Félix Castello, Eugenio Caxés, Antonio Puga, Jusepe Leonardo, Juan Bautista del Maino and Antonio de Pereda all worked on the depictions of battles. Velázquez was commissioned to paint the equestrian portraits and *The Surrender of Breda* (1634–35; Prado Museum).

A comparison with other works produced for the Hall of the Kingdoms, despite the general high artistic level, eloquently demonstrates the extent to which Velázquez surpassed his fellow countrymen. For its time, *The Surrender of Breda* was unparalleled both in its treatment of a historical

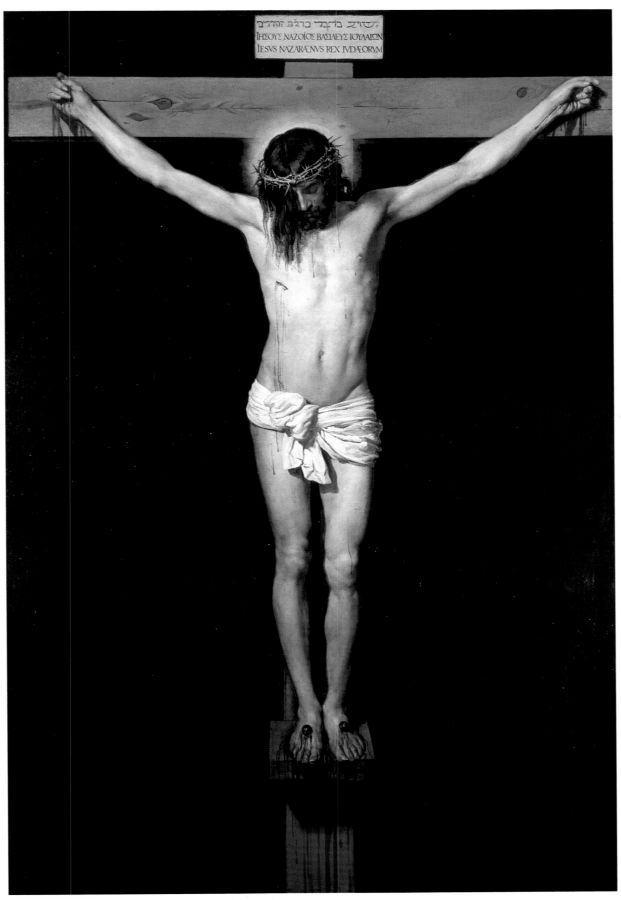

*CHRIST ON THE CROSS.* 1631–32
Oil on canvas. 248 x 169 cm
Prado Museum, Madrid

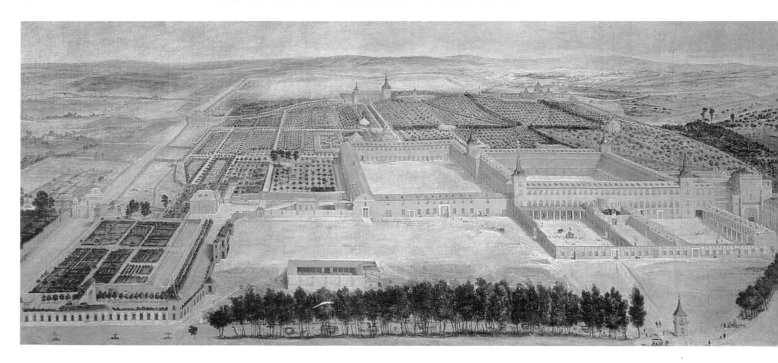

Attributed to Jusepe Leonardo
*THE BUEN RETIRO PALACE AND GARDENS.* Ca 1637
Royal Palace, Madrid

event and in the novelty of its artistic conception. Spanish forces under the command of the Genoese general Ambrogio Spinola won a victory over the Dutch fortress of Breda in 1625. Velázquez could only have known the details of the siege from the general himself, with whom he was acquainted. When he was working on the canvas, Spinola was no longer alive (he died in 1630). In painting the work, Velázquez paid him a tribute of deep respect. Breda was a mighty fortress which the Dutch defended with incredible courage, and, although they ultimately surrendered, they displayed valour and daring in the battle. While dedicating the painting to the victory of the Spanish army, Velázquez at the same time expressed the thinking of most reasonable contemporaries, who considered the war with Holland to be senseless and, essentially, already lost.

The composition of the painting is very restrained and is not cheapened by either the false pathos or the bombastic effects which so tempted painters of battle scenes in the Baroque period. The painting depicts the Spanish on the one side, and the Dutch on the other. A forest of lances belligerently pointing to the skies, creates an impression of great numbers and order in the Spanish army (on account of this detail the painting acquired a second title, *Las Lanzas – Lances*). The victorious soldiers, poised confidently, are vividly characterized. The Dutch, their lances and halberds in disarray, are in sharp contrast to the refined, delicate grandees, squeezed in behind Spinola. The central scene is very expressive. Slowly, with a heavy step, the courageous Justin of Nassau, who himself often defeated the Spanish, approaches Spinola in order to hand him the key to the fortress. The Spanish commander-in-chief, aware of the drama taking place in the mind of his adversary, bows in a sympathetic manner as he meets him. In the whole history of art it is difficult to find a work imbued with such a lofty notion of nobility and chivalry as

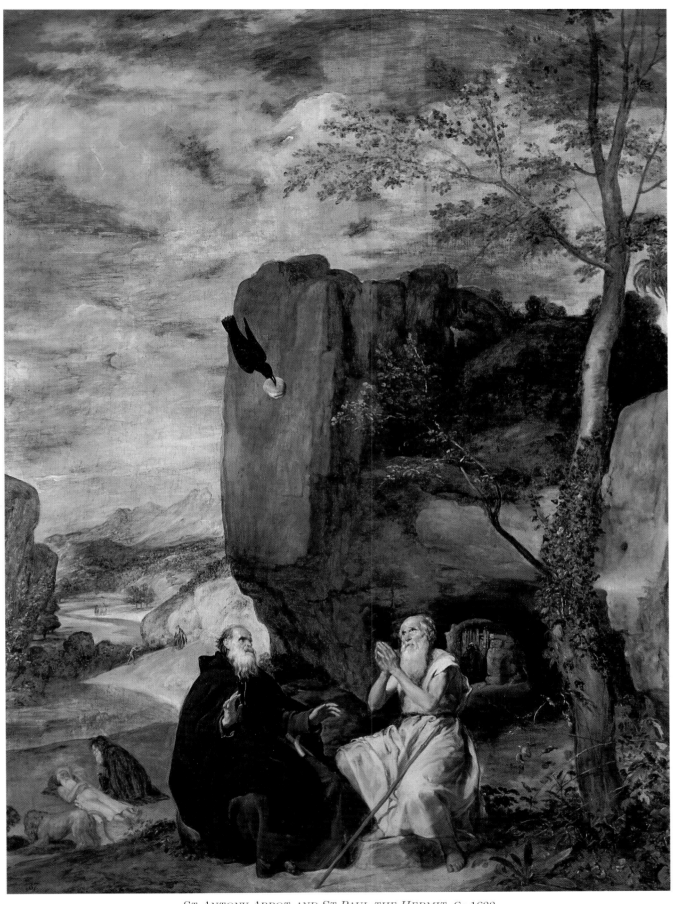

*ST ANTONY ABBOT AND ST PAUL THE HERMIT.* Ca 1633
Oil on canvas. 257 x 188 cm
Prado Museum, Madrid

73

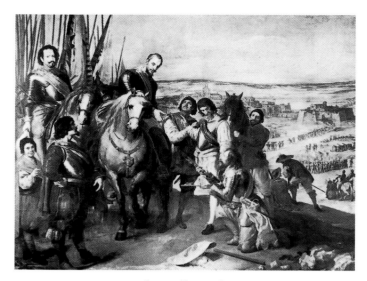

Jusepe Leonardo
*THE SURRENDER OF JULIERS.* Ca 1635
Prado Museum, Madrid

Francisco de Zurbarán
*THE DEFENCE OF CÁDIZ.* 1634
Prado Museum, Madrid

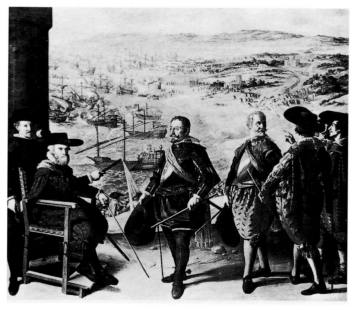

*The Surrender of Breda.* The action takes place in the wide expanse of a plain. The unlimited space is communicated with striking dexterity: the smoke from fires not yet extinguished is visible in the distance, the widely flooding waters of the river, the sluices of which were opened to aid the defence of the fortress, and the horizon merging with the skies. The brushwork is differentiated depending on the planes: the figures are densely painted, while the distant fortress and hills are barely traced.

The royal equestrian portraits were created from the end of the 1620s onwards, and it is believed that three of them – of Philip III, Margaret of Austria and Isabel of Bourbon (all in the Prado Museum) – were painted not by Velázquez, but by other court painters: Velázquez only reworked them, adapting them for the Buen Retiro. Probably, the portrait of Philip IV, and certainly that of Prince Baltasar Carlos, were produced specially for the Hall of the Kingdoms. In terms of composition the equestrian portrait of Philip IV (1634–35; Prado Museum) is the most traditional. It repeats the scheme of Titian's *Charles V*, only the angle from which the horse is depicted has altered. The portrait of the King radiates majestic grandeur. However, Velázquez also captures the monarch's character in this work: languid, apathetic and weak-willed. A combination of majesty and devaluation of the monarch's image is conveyed in both portraits. The pronounced family likeness of the faces with strongly jutting jaws, sharply brings into relief the difference in personality between the two monarchs: Charles V is collected, energetic, his firmness of purpose expressed through his movement, while his great-great-grandson poses stiffly. Velázquez possessed a unique ability to perceive a model with detachment and to reproduce him in an unidealized manner. He inherited this from a long tradition of Spanish court portrait

painters. The Spanish monarchy looked tolerantly upon the truthful reflection of their character in portraits, valuing a good resemblance and not demanding an idealized depiction of themselves. (At the end of the eighteenth century, Goya would take this "warts and all" approach to an almost satirical level.) The equestrian portrait of Philip IV is the first instance of Velázquez expressing the increasingly negative aspects of the King's character, a feature which became more pronounced in his art as time went on.

When the model was attractive to the artist, however, he brought out the person's charm unreservedly. The equestrian portrait of the five-year-old Prince Baltasar Carlos (1634–35; Prado Museum) is one such work, which shows no trace of constraint. The small horseman gallops away at full speed, a commander's baton in his raised hand, his face stern and serious, yet the overall impression is of true childish play. The painting was to hang above a door, and the artist took this into account in foreshortening the horse. The manner of painting in both portraits (Philip IV and Baltasar Carlos) is expansive, free and strikingly beautiful in colour. The landscape painted from life is saturated with light and air.

The equestrian portrait of Conde-Duque de Olivares (1635–38; Prado Museum) is closely related to the royal portraits of the Buen Retiro Palace. Olivares is depicted in armour upon a rearing horse; in the distance the smoke of a battlefield is visible. The Conde-Duque never participated in warfare himself, but as the head of government he considered himself instrumental in all the Spanish victories. It is not accidentally that in his painting, *The Recapture of Bahía de San Salvador* (1634–35; Prado Museum), Juan Bautista del Maino included a tapestry depicting Olivares crowning Philip IV with a laurel wreath, the very act emphasizing

Juan Bautista del Maino
*THE RECAPTURE OF BAHÍA DE SAN SALVADOR.* 1634–35
Prado Museum, Madrid

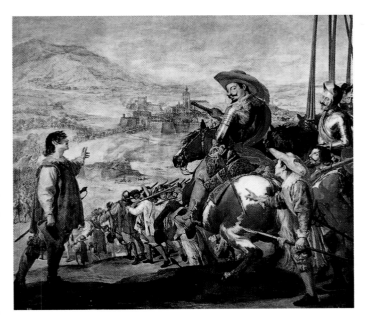

Jusepe Leonardo
*THE CONQUEST OF BREISACH.* 1634–35
Prado Museum, Madrid

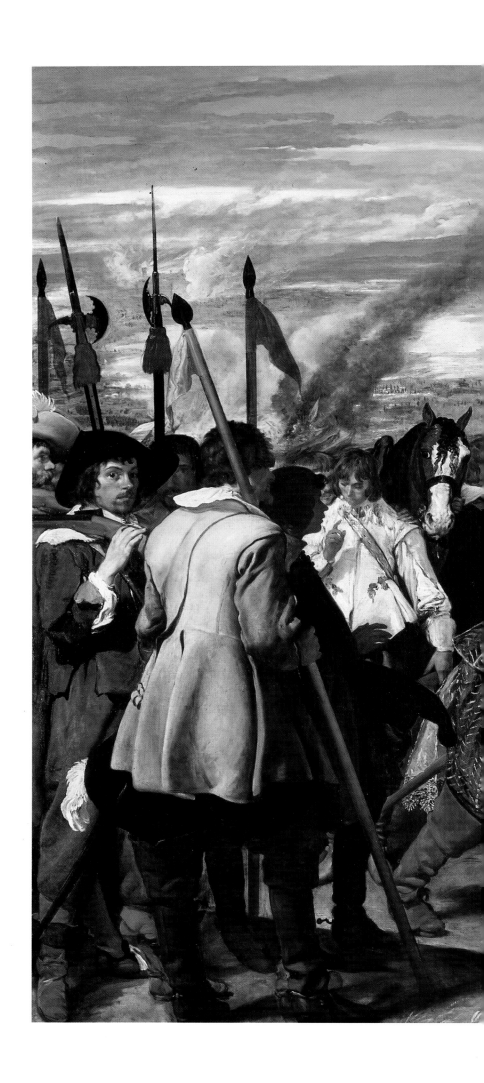

*THE SURRENDER OF BREDA.* 1634–35
Oil on canvas. 307 x 367 cm
Prado Museum, Madrid

76

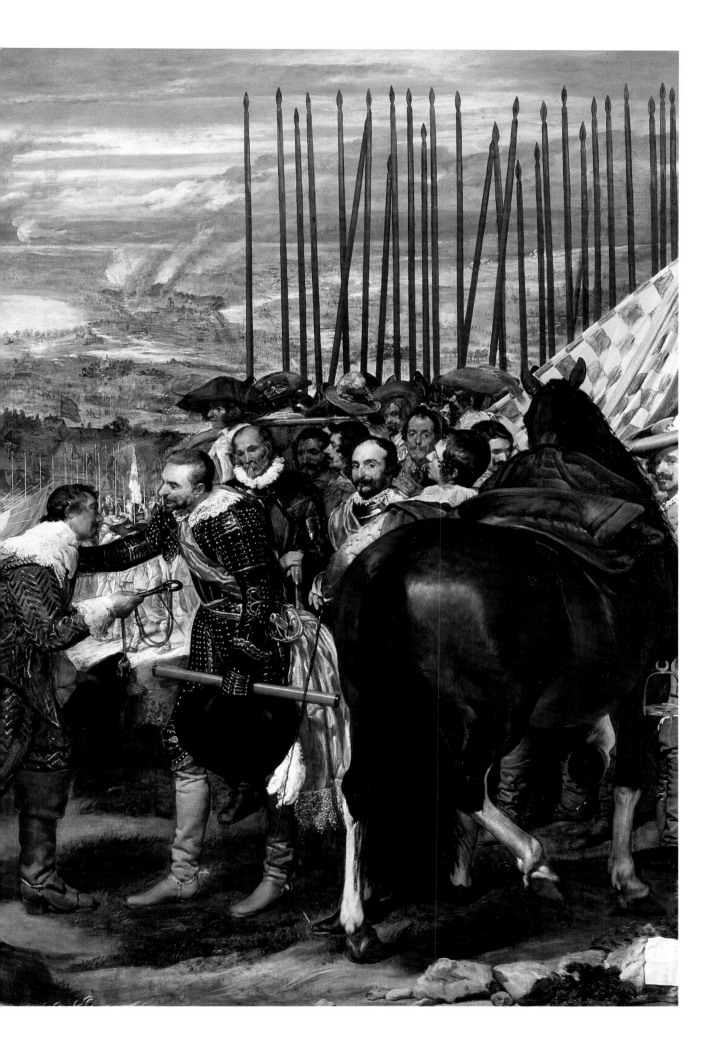

*PHILIP III ON HORSEBACK.* 1628–35
Oil on canvas. 300 x 314 cm
Prado Museum, Madrid

*PHILIP IV ON HORSEBACK.* 1634–35
Oil on canvas. 301 x 318 cm
Prado Museum, Madrid

*QUEEN MARGARET OF AUSTRIA
ON HORSEBACK.* 1628–35
Oil on canvas. 301 x 314 cm
Prado Museum, Madrid

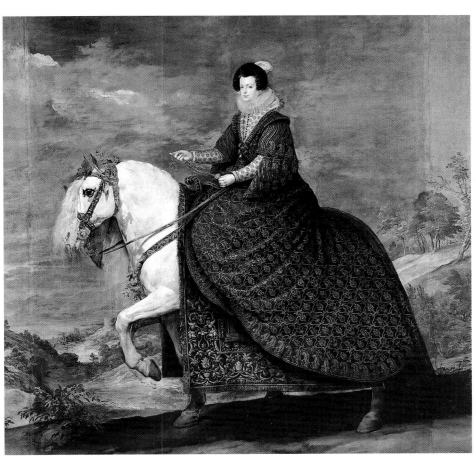

*QUEEN ISABEL OF BOURBON
ON HORSEBACK.* 1628–35
Oil on canvas. 301 x 314 cm
Prado Museum, Madrid

the Conde-Duque's role in the victory. The idea of creating the Hall of the Kingdoms, decorated with paintings celebrating the victories of the Spanish army, came from Olivares. His desire to see himself in an equestrian portrait against the backdrop of a battle was thus quite natural. There is good reason to suppose that Velázquez painted it at the same time as the royal portraits, as the styles are very close. Jusepe Leonardo produced a similar depiction of Olivares galloping on a horse in his *Conquest of Breisach* (1634–35; Prado Museum). The view of the horseman from the back in the painting is so original that it is difficult to believe that Velázquez and Leonardo both drew on some other iconographic source: it seems more likely that the latter repeated Velázquez's motif. Olivares is depicted in the prime of life, as he still was in the first half of the 1630s. Towards the end of the 1630s the Conde-Duque aged suddenly and changed greatly. Nevertheless many art historians are inclined to carry over the date of Olivares' equestrian portrait to 1638, when the victory over the French at the battle of Fuenterrabía was celebrated. Although Olivares did not participate in that battle, he personally took charge of the army from Madrid and sent specially trained troops to Fuenterrabía. Even if the equestrian portrait of Olivares was executed in 1638, the artist nonetheless portrayed the Conde-Duque as he looked earlier.

Olivares was an excellent horseman. He taught the King and subsequently Prince Baltasar Carlos how to ride. Velázquez paid tribute to Olivares' energy and determined character in this painting. The effect of turbulent movement is emphasized: the horse is moved into the depth of the canvas, while the horseman turns around to look at the viewer. These different directions of movement accentuate the figure's energy. The image of Olivares is heroic and noble.

In this regard it was cast in the same mould as the royal equestrian portraits for the Buen Retiro Palace.

Concurrently Velázquez painted a work in which he captured the daily routine of the royal family, *Prince Baltasar Carlos in the Riding School* (ca 1635; Grosvenor Estate, Cheshire). The action takes place against the backdrop of the Buen Retiro Palace, with its modest brick façade lending a prosaic tone to the entire work. In the foreground, Prince Baltasar Carlos, gallops confidently on a horse; on the left, behind the horseman is a dwarf, and to the right, Conde-Duque de Olivares. Alonso Martínez del Espinar, the Prince's bearer of arms and page, hands him a lance; behind him is Juan Mateos, the Master of the Hunt. On the distant balcony the figures of the King, Queen and other members of the court can just be divined. On the whole the work is like an illustration of the daily life of the court. This painting was the first of its kind in Spanish royal portraiture. In producing such a canvas, Velázquez entered a new phase of his art, in which painting was no longer exclusively a means of ennobling his figures, of rendering them heroic or idealized. It opened unlimited possibilities for the brilliant Spanish painter.

Agents in Spain, Italy and Flanders bought up paintings, tapestries and furniture to decorate the Buen Retiro Palace. The artists of Madrid also received assignments for paintings of secular nature. Apart from the Hall of the Kingdoms Velázquez painted a series of portraits of jesters to be installed in the Queen's apartments. They were listed in the inventory of the Buen Retiro Palace in 1701. At the present time three of them have been identified – *The Buffoon Pablo from Valladolid*, *The Buffoon called "Don Juan de Austria"* and *The Buffoon Christóbal de Castañeda y Pernia, called "Barbarroja"*. Neither the biographies

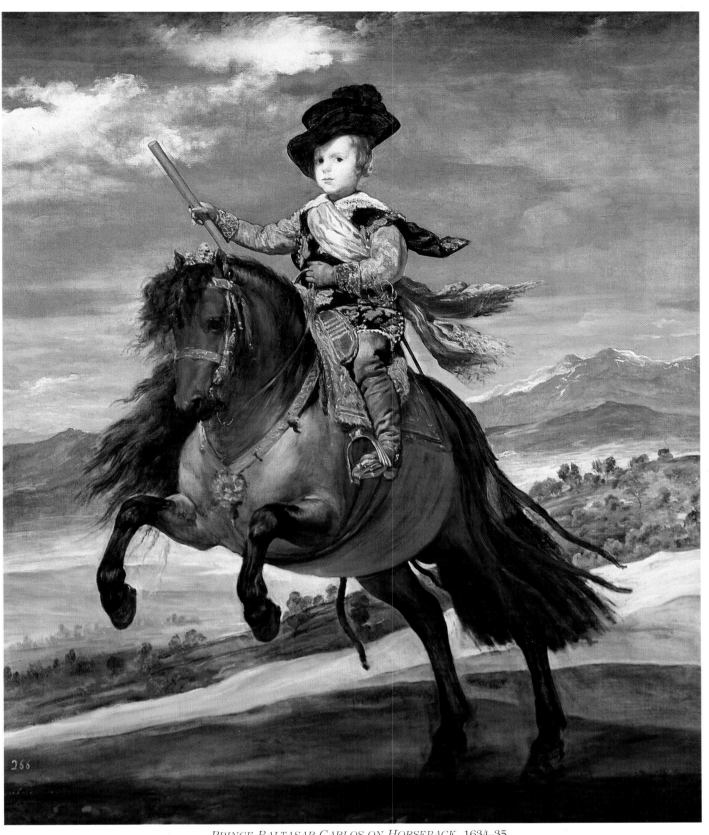

*PRINCE BALTASAR CARLOS ON HORSEBACK.* 1634–35
Oil on canvas. 209 x 173 cm
Prado Museum, Madrid

Juan Bautista del Maino
*THE RECAPTURE OF BAHÍA DE SAN SALVADOR.* 1634–35.
Detail

of those depicted nor the stylistic peculiarities of the portraits contradict the supposition that they were created in the mid-1630s. *The Buffoon called "Don Juan de Austria"* (ca 1635–40; Prado Museum) depicts a jester who lived at the Spanish court from 1624 to 1654. His real name is unknown; he received his nickname by association with Don Juan of Austria, the illegitimate son of Charles V, a famous warrior, victor of the naval battle at Lepanto. The jester is depicted against a background of naval warfare. The composition recalls the court portraits of the sixteenth century: the figure is portrayed full length in the enclosed space of a room, with a window overlooking a landscape. But the pose of the figure, his clothes and the objects untidily scattered on the floor betray something of the ironic attitude of those around him. Evidently a companion piece to this work was *The Buffoon Christóbal de Castañeda y Pernia, called "Barbarroja"* (Prado Museum), a name which is encountered in court documents from 1633. He was dubbed Barbarroja (Barbarossa) after the Turkish pirate, Khair ed-Din, who was defeated at Lepanto. Castañeda's daring jokes earned him his nickname. He is depicted in Turkish dress and a jester's cap. The likeness of Castañeda is painted like an official full-length portrait in an interior. His decisive, courageous nature is excellently rendered. It was he who, in the presence of the King, responded to the question as to whether there were any olives by saying: "No, neither olives nor Olivares," for which he was exiled to Seville in 1634. Since the portrait remained uncompleted its dating is problematic, but it cannot be excluded that it was painted in 1634.

"Pablo from Valladolid" lived from 1633, with his two children, in the Alcázar. There is nothing of the jester in his appearance in the portrait (ca 1634; Prado Museum), and

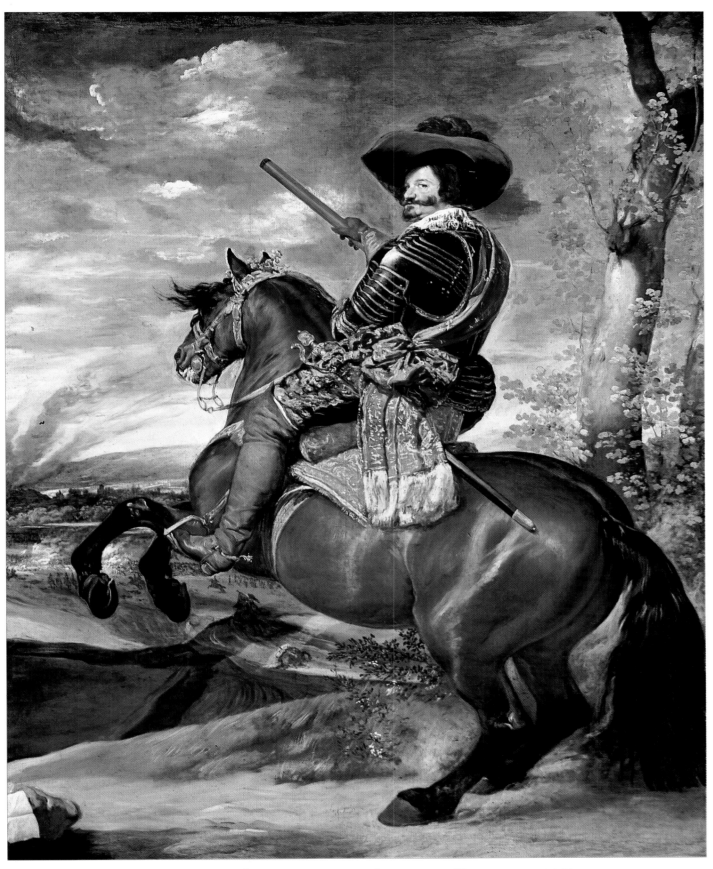

*GASPAR DE GUZMÁN, CONDE-DUQUE DE OLIVARES, ON HORSEBACK. 1635–38*
Oil on canvas. 313 x 239 cm
Prado Museum, Madrid

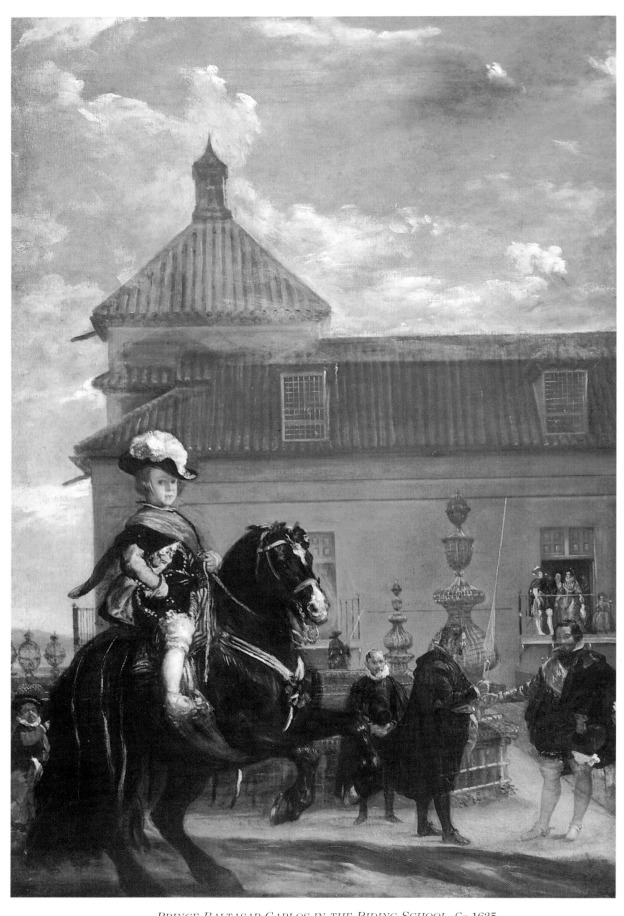

*PRINCE BALTASAR CARLOS IN THE RIDING SCHOOL.* Ca 1635
Oil on canvas. 144 x 91 cm
The Grosvenor Estate, Cheshire

if his contemporaries had not recalled him as a buffoon, this fact would have been hard to infer from the painting. The very expressive pose and gesture betray a great actor in him. In this work Velázquez used the device of silhouette, depicting a figure in black set against a brightly lit background stripped of concrete definition.

Velázquez was a pioneer in his depiction of jesters. Prior to him, "people of entertainment", as they were called at the court, had never been an object of artists' attention. He perceived them not only as amusing performers, but as personalities with a vividly expressed individuality in character and manner. An equestrian statue of Philip IV was planned to decorate the park of the Buen Retiro. The commission was placed with Pietro Tacca in Florence and a portrait by Velázquez was sent as a guide to the sculptor. A sculpted bust of the King was also required and Juan Martínez Montañés, considered to be the best Spanish sculptor, was engaged to make it. He arrived in Madrid from Seville in July 1635 and stayed in the capital until January 1636. Velázquez was well acquainted with him from the days when he lived in Seville. Pacheco included Martínez Montañés in his book of illustrious contemporaries. Velázquez painted him at work on the bust of Philip IV (1635–36; Prado Museum). A precedent for such a painting existed in the portrait of the sculptor Pompeo Leoni creating the bust of Philip II (Sterling-Max Collection). That work was attributed to El Greco, although at present the identity of the author is being called into question. Nevertheless, the work was produced in sixteenth-century Spain, and it is very likely that Velázquez was acquainted with it. El Greco's portrait of Jorge Theotokopoulos, his son (1600–05; Museo Provincial de Bellas Artes, Seville), could also have been known to him. Like those works, in which the profession of the artist

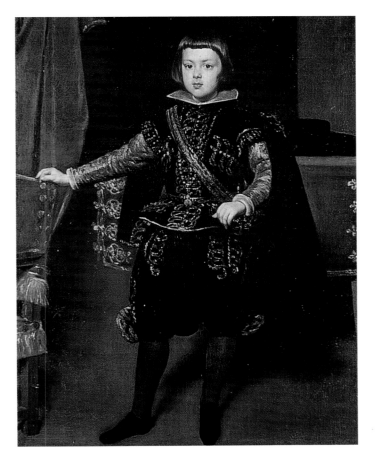

School of Velázquez
*PRINCE BALTASAR CARLOS.* Ca 1639
Oil on canvas. 128.5 x 99.5 cm
Kunsthistorisches Museum, Vienna

is underscored, the depiction of the sculptor Martínez Montañés elevates the image of the sculptor. The portrait is not formal and concentrates on the sculptor as a person rather than on his craft. However, Velázquez's respect for the model's talent is clearly apparent in the work. The portrait was not completed, the sculpted bust is only hinted at, but as a whole, we can admire in this painting Velázquez's virtuosity as a draftsman. The portrait of the Master of the Hunt, Juan Mateos (1634; Gemäldegalerie, Dresden), is also informal and intimate in its approach. The Master of the Hunt was a very important figure at court, since hunting was a favourite pastime of the Spanish kings. Juan Mateos was the author of *Origen y Dignidad de la Caça (The Origin*

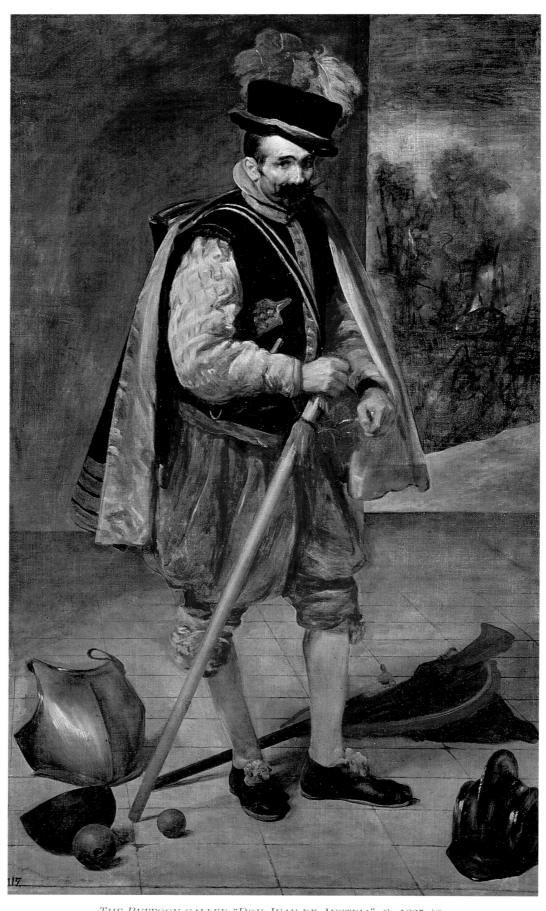

*THE BUFFOON CALLED "DON JUAN DE AUSTRIA".* Ca 1635–40
Oil on canvas. 210 x 123 cm
Prado Museum, Madrid

86

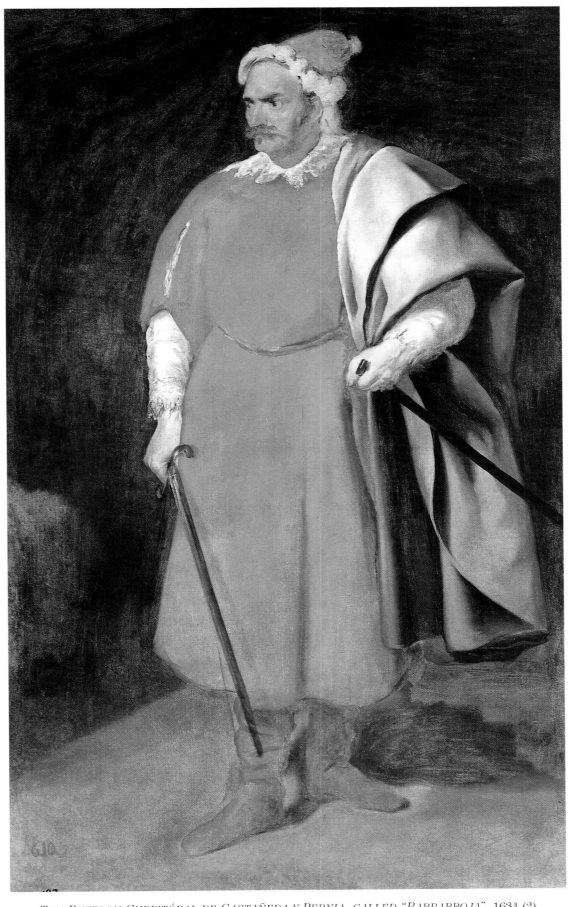

*The Buffoon Christóbal de Castañeda y Pernia, called "Barbarroja". 1634 (?)*
Oil on canvas. 198 x 121 cm
Prado Museum, Madrid

*JUAN MATEOS VÁZQUEZ. MASTER OF THE HUNT.* Ca 1634
Oil on canvas. 108 x 89.5 cm
Gemäldegalerie, Dresden

*THE BUFFOON PABLO FROM VALLADOLID.* Ca 1634
Oil on canvas. 209 x 123 cm
Prado Museum, Madrid

Attributed to El Greco
*THE SCULPTOR POMPEO LEONI WORKING
ON THE BUST OF PHILIP II.* 1577–80
Whereabouts unknown

El Greco
*JORGE THEOTOKOPOULOS.* 1600–05
Museo Provincial de Bellas Artes,
Seville

*and Importance of Hunting*), published in Madrid in 1634. Judging by the engraved portrait of the author that appears in the book, it is very probable that Velázquez completed the portrait at about the same time. Mateos rests one hand on his rapier; the other holds a pistol. He is presented not heroically, but, on the contrary, in a very restrained and modest manner. The Master of the Hunt is in a severe black costume against a background devoid of accessories. All the attention is focused on his face. El Greco, for whom the spiritual aspect of a figure was of primary importance, first introduced this type of portrait into Spain. In the depiction of Juan Mateos, Velázquez continued the tradition established by his illustrious predecessor.

*THE SCULPTOR MARTÍNEZ MONTAÑÉS.* 1635–36
Oil on canvas. 109 x 83.5 cm
Prado Museum, Madrid

*PHILIP IV AS HUNTSMAN.* 1635–36
Oil on canvas. 191 x 126 cm
Prado Museum, Madrid

Construction of the hunting pavilion of the Torre de la Parada began in 1635, when the Buen Retiro Palace had not yet been completed. The new residence was intended not only for the preparation of the hunt, but also for resting and receptions. In the sixteenth century, under Philip II, a tower had been erected on the estate of El Pardo Palace, which was located not far from Madrid, and it was now decided to surround it with buildings. The architectural works were entrusted to Juan Gómez de Mora. In Flanders the Cardinal Infante Ferdinand gave Rubens the task of turning out more than fifty paintings on mythological subjects with depictions of landscapes and animals. Rubens produced preliminary sketches from which artists in his studio, including Frans Snyders, Jacob Jordaens and Pieter de Vos, worked. In 1638 the canvases began to arrive in Spain. Velázquez also took part in the decoration of the Torre de la Parada according to a document dating from December 1636, in which he requested payment for works commissioned for the building. The artist subsequently continued to create works for the Torre de la Parada. The large

## THE TORRE DE LA PARADA 1635–1640

Attributed to Félix Castello
*THE TORRE DE LA PARADA.* Ca 1637
Museo Municipal, Madrid

hall, called the King's Gallery, was decorated with Velázquez's *Philip IV Hunting Wild Boar* and royal portraits in hunting attire. The canvas *Philip IV Hunting Wild Boar* (*ca* 1635–36; National Gallery, London) was unique for its time, in the same way as *Prince Baltasar Carlos in the Riding School.* since its sole purpose was to capture an episode in the life of the royal court. The specific landscape depicted in *Philip IV Hunting Wild Boar* is filled with a profusion of figures, embraced at a single glance. The King, Conde-Duque de Olivares, the Master of the Hunt, Juan Mateos, as well as the Queen seated in a carriage, can be recognized among the small figures, but the artist does not pay them too much attention. The largest figures, which he depicted in the foreground, are the grandees actually participating in the hunt. The excitement of the occasion is expressed through the disorderly arrange-

ment of the characters, some with their faces and others with their backs turned towards the viewer. The artistry with which the painter captured not only the human figures, but also horses and dogs, in a few brushstrokes reveals the extent of his talent.

*PHILIP IV AS HUNTSMAN.* Detail

94

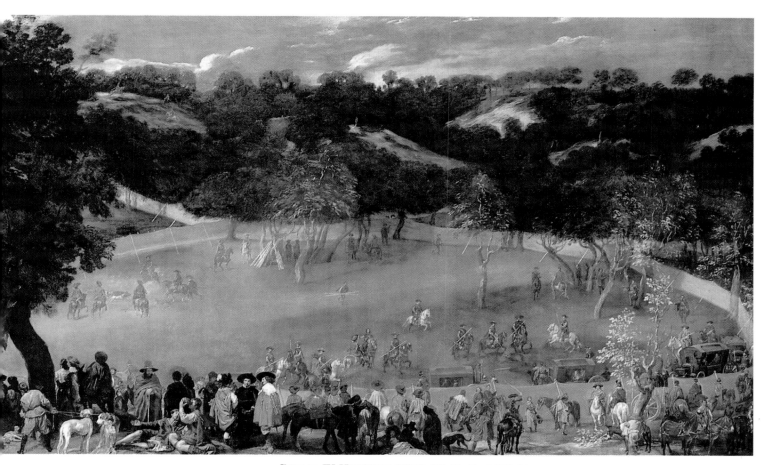

*PHILIP IV HUNTING WILD BOAR.* Ca 1635–36
Oil on canvas. 182 x 302 cm
National Gallery, London

*THE CARDINAL INFANTE FERDINAND AS HUNTSMAN.* Detail

96

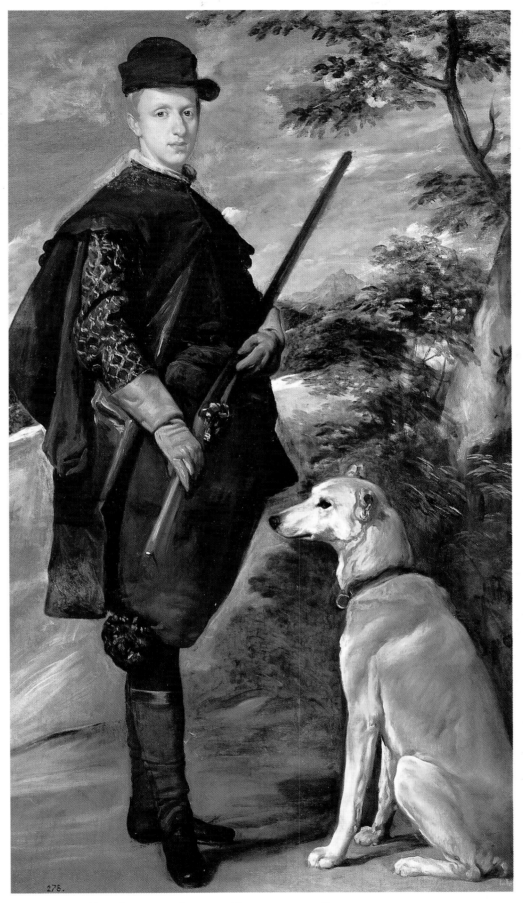

*THE CARDINAL INFANTE FERDINAND AS HUNTSMAN.* 1635–36
Oil on canvas. 191 x 107 cm
Prado Museum, Madrid

The painting is one of Velázquez's most candid, anticipating the works of nineteenth-century painters, for whom reality in its daily manifestation would be of primary interest. At the end of the eighteenth century, Goya highly valued such paintings by Velázquez and his assistants. He obviously drew on them when he painted scenes of folk festivities. Edouard Manet, evidently under Velázquez's influence, employed figures painted in a sketch-like manner. Unfortunately, *Philip IV Hunting Wild Boar* is badly preserved and the painting has required major restoration work.

The royal portraits produced for the Torre de la Parada Palace, in contrast to the official depictions for the Buen Retiro, are of a private nature. In this regard it is difficult to find analogies for them not only in Spanish painting, but also in the art of other countries at the time. In the canvas of 1635–36 (Prado Museum) Philip IV, in hunting dress, stands easily, one hand placed on his waist and pointing his gun downwards. His face is similar to that in the 1631–32 portrait, called *"The Silver Philip"*; he looks more natural and alluring than in the equestrian portrait produced for the Buen Retiro Palace. The King is here portrayed against a background of a mighty tree trunk with which his figure merges generating an impression of monumentality and steadfastness. A large pedigree dog on the left completes this effect.

The portrait of the Cardinal Infante Ferdinand (1635–36; Prado Museum) is treated somewhat differently. A younger brother of Philip IV, Ferdinand (Fernando), was elevated to the dignity of cardinal in 1619 at the age of ten. Until 1632, all three brothers – Philip, Carlos and Ferdinand – lived together in Madrid. In the summer of 1632 they all travelled to Valencia, and then to Catalonia, where the Cardinal Infante remained in the capacity of viceroy. Shortly after, Carlos

died unexpectedly. In 1633 the Infanta Isabel, the regent of Flanders, died and Ferdinand was appointed as her successor. He still remained for a while in Spain, before making his triumphal entry into Antwerp in April 1635. He did not return to Madrid, however, and if Velázquez painted his portrait, he could only have done so before 1632. It is evident that for the portrait of the Cardinal Infante in hunting attire intended for the Torre de la Parada, he used a depiction of Ferdinand created earlier: the young appearance of the subject, without a moustache (in 1636 he was already twenty-six), testifies to this. Ferdinand was an energetic character, very different from the phlegmatic Philip and this comes across in the portrait: the pose is more dynamic, as Ferdinand confidently wields a fowling piece, while the dog at his side, pricked up its ears, sniffing the game. The landscape is painted without much attention to detail, and if one compares the treatment of the leaves in the trees with those in the superb landscape in *St Antony Abbot and St Paul the Hermit* (*ca* 1633), one can assess the evolution of Velázquez's painting style: from the delicate working out of foliage in the first canvas, he moved on to the depiction of a green mass.

In the portrait of Baltasar Carlos in hunting dress (1635–36; Prado Museum), the inscription states that the Prince was six years old, and, of course, this likeness was painted from life. A year had passed since the creation of the equestrian portrait, in which Philip's heir was still every bit a child. Here the artist captured the more mature appearance of the young Prince. The hunting dress, the cap turned to the side, the gloves and the lace collar confer an elegance to the boy, while at the same time his appearance has not lost its childishness. The canvas is cut off on the right – originally three dogs were depicted there. Now the head of only one dog, on guard, is visible to the right,

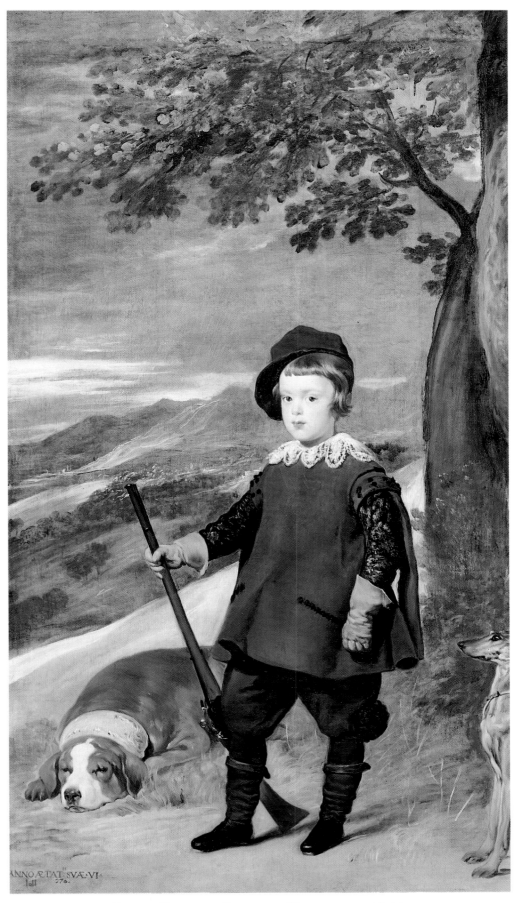

*PRINCE BALTASAR CARLOS AS HUNTSMAN.* 1635–36
Oil on canvas. 191 x 103 cm
Prado Museum, Madrid

Hendrick Terbrugghen
*MARS AT REST*. 1629
Centraal Museum, Utrecht

and to the left a large gundog expresses its devotion through its entire demeanour. The grey clouds of an autumn day merge with the grey contours of the mountains; the outline of the slope, against which Baltasar Carlos is depicted, is repeated in the landscape, creating an illusion of movement. This motif, intuitively introduced by the artist, strikingly corresponds to the nature of childhood, with its disinclination to remain calm.

Velázquez also painted works, associated with the classical world – *Mars. Aesop* and *Menippus* – for the Torre de la Parada, where the interior decoration was dominated by the paintings on mythological themes sent from Flanders. Velázquez's canvases were all of one size; all were listed in the 1701 inventory of the Torre de la Parada. It is difficult to pass judgement on the intention behind these and other Velázquez's works

dealing with classical subjects – *Bacchus and His Companions* and *Apollo in the Forge of Vulcan*. Undoubtedly, in these works the artist was fulfilling some kind of assignment, but whose and why the particular subjects were chosen remains a mystery. Several researchers are inclined to perceive the depiction of *Mars at Rest* (ca 1636–40; Prado Museum) as a continuation of the tale in *Apollo in the Forge of Vulcan*, since the naked god of war in a helmet, with discarded armour at his feet, sits on a bed, discouraged, as if he had been caught by Vulcan in a compromising situation with Venus. The only thing that one can assert with certainty is that here, as in the earlier works, Velázquez merges antiquity and his own time. He paints the mythological figure in such a way that the latter seems to live in the seventeenth century. The perplexed face of Mars, with its round eyes and long moustache turned up at the ends, betrays the artist's humorous attitude towards him. Velázquez was not alone in portraying the god of war as a contemporary figure. In the work of Hendrick Terbrugghen, *Mars at Rest* (1629; Centraal Museum, Utrecht), for example, the classical god of war is also modernized. Velázquez worked in the framework of the general perceptions of his time, although his approach to subjects was always original. The powerful treatment of the muscular body in Velázquez's *Mars at Rest* echoes Michelangelo's figures, but the profusion of folds in the fabric and the wealth of light-and-colour correlations reflect the mature Baroque style.

Two other classical figures from the Torre de la Parada – Aesop and Menippus – are identified only through the inscriptions on the works, as it would otherwise be difficult to determine who was depicted. Here Velázquez followed the notions of his time. Ribera, for example, painted classical philosophers in the guise of beggars from

*MARS AT REST.* Ca 1636–40
Oil on canvas. 179 x 95 cm
Prado Museum, Madrid

Jusepe de Ribera
*DEMOCRITUS* (traditionally known as *ARCHIMEDES*). 1630
Prado Museum, Madrid

the streets of Naples. His *Democritus*, earlier known as *Archimedes* (Prado Museum), was completed in 1630, when Velázquez was in Naples. Furthermore, Ribera executed a series of ragged philosophers on order from the Duke of Alkalá. The idea was probably suggested to the artist by that same enlightened erudite noble. Velázquez must also have been acquainted with the Duke of Alkalá whom he could have met in Seville, Naples and Madrid, where the Duke arrived in May 1631. Creating the paintings *Aesop* and *Menippus* (ca 1636–40; Prado Museum) for the Torre de la Parada,

the artist followed in Ribera's footpath, although admittedly the latter depicted the philosophers half-length, while Velázquez worked on large monumental canvases, preferring to depict his subjects full-length.

The choice of Aesop can be explained by the plethora of works on themes from his fables, which decorated the Torre de la Parada. According to surviving descriptions, Aesop was an unprepossessing, even ugly figure and the artist found a real person who corresponded to his notions about Aesop as he obviously painted the work from a sitter. Despite the fact that Velázquez emphasized the figure's defects, the disarray of his clothes and the wretchedness of his accessories lying on the floor, he simultaneously conveyed his deep respect towards the man. His face is large, rather massive – unusually expressive: intellect, life experience and the stamp of an onerous fate are written upon it.

Menippus, the cynic and satirist, is characterized in a different way. It is not clear why that particular philosopher was chosen to serve as a character for a companion piece to *Aesop*. While Aesop personifies wisdom and equanimity, Menippus reflects malevolence and malice. His facial features are emphasized sharply and the asymmetrical eyes fix the viewer with a penetrating look; a large, heavy nose reaching down almost to the mouth, the upper lip of his toothless mouth collapsed. The brushwork is soft and flowing, the forms are conveyed in a plastic manner, without sharp contours. The technique reflected the increasing influence of the Flemish masters, which became apparent in Velázquez's work at the end of the 1630s.

In the representation of the jesters or of such characters as Aesop and Menippus, Velázquez had a freer rein than in his depictions of the royal family and the aristocracy.

*AESOP.* Detail

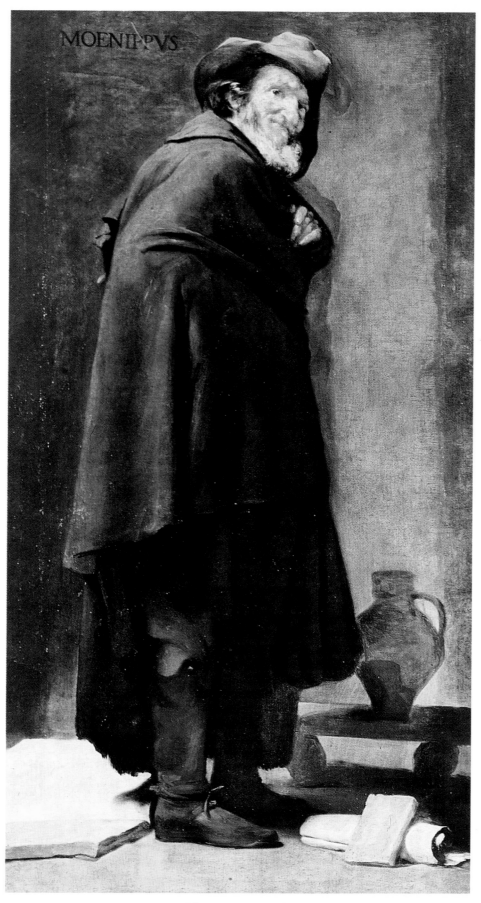

MENIPPUS. 1636–40
Oil on canvas. 179 x 94 cm
Prado Museum, Madrid

*AESOP.* Ca 1637–40
Oil on canvas. 174 x 94 cm
Prado Museum, Madrid

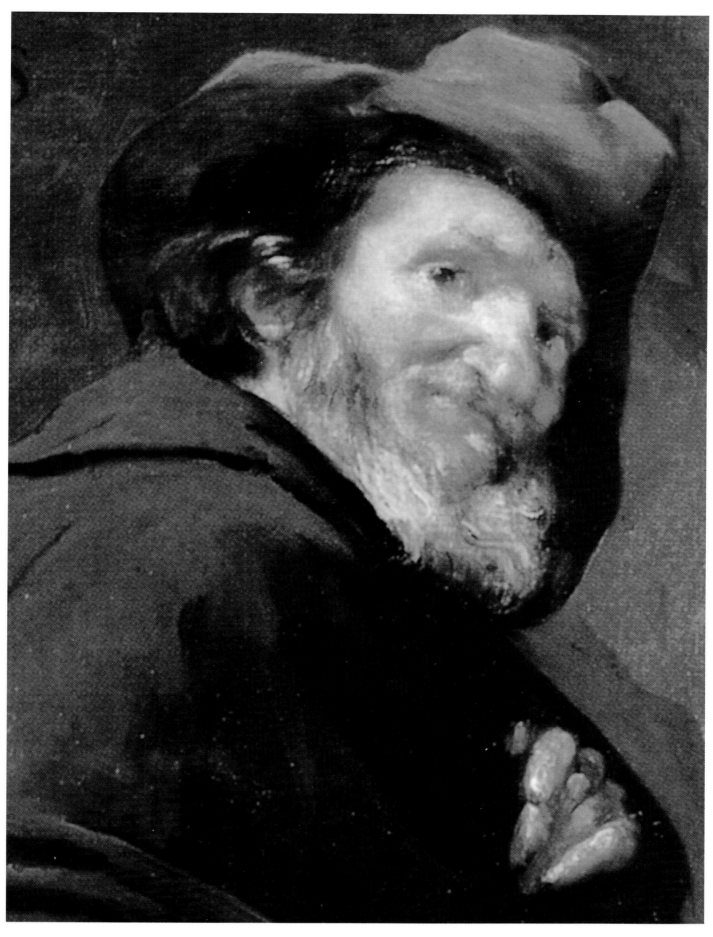

*MENIPPUS.* Detail

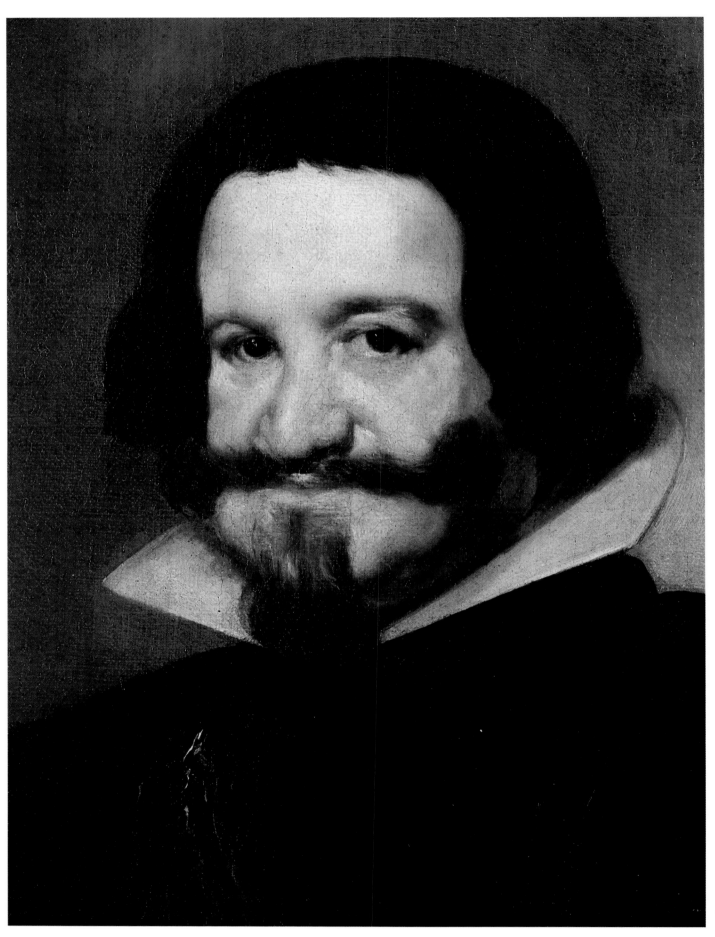

*CONDE-DUQUE DE OLIVARES.* Detail

Attributed to Diego Velázquez
*CONDE-DUQUE DE OLIVARES*
Drawing
Ecole des Beaux-Arts, Paris

Herman Panneels
Engraving from Velázquez's painting
*Conde-Duque de Olivares*. 1638

108

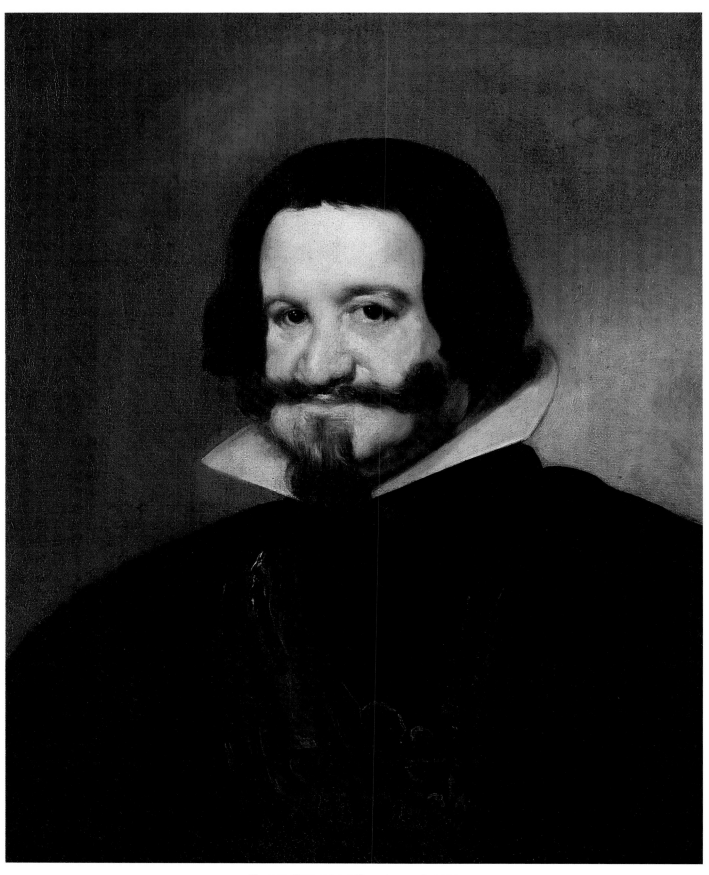

*CONDE-DUQUE DE OLIVARES.* Ca 1638
Oil on canvas. 67 x 54.5 cm
The Hermitage, St Petersburg

Nevertheless, in the latter the artist at times managed to unveil the complexity of his subjects' personalities. The portrait of Juan Mateos has already been mentioned. The portrait of Conde-Duque de Olivares (ca 1638; Hermitage, St Petersburg) is another such work. An engraving by Herman Panneels, signed: *Ex Archetipo Velázquez Herman Panneels F. Matriti 1638* (from the original by Velázquez Herman Panneels made [this], Madrid), was published in Juan Antonio de Tapia y Robles' book, *Ilustración del Renombre de Grande* (*Depictions of Illustrious Grandees*), which appeared in Madrid in 1638. All art historians agree that the engraving was produced from the Hermitage painting; other variants of the portrait have been assigned to Velázquez's studio.

The artist observed the Conde-Duque over many years. He painted him at the height of his power, ennobling him and rendering him in a heroic fashion. In the half-length portrait Velázquez provided a most candid depiction of Olivares revealing his multi-faceted nature. Ambition, vainglory, love of power, boundless energy and a tremendous capacity for work were combined in the Prime Minister with despotism, a striving after absolute power and an impatience with regards to other people's opinions. Overwhelmed with the ardent desire to see Spain as powerful as in the sixteenth century under Charles V and Philip II, the Conde-Duque drew the country into war and wasted huge sums of money on the construction and decoration of palaces at a time when the country was already undergoing an economic crisis. The necessary expenditures were met by an increase in taxation. Both his closest entourage and the nation as a whole hated Olivares. All his attempts at economic reforms were fruitless. The military victories so triumphantly presented by artists in paintings for the Hall of the Kingdoms were little more than fiction.

In 1637 the Dutch recaptured Breda; in 1638 Breisach was lost; in 1635 the war with France began; Catalonia rebelled and Portugal strove for independence.

Hard times befell the Conde-Duque in the late 1630s. He was by then around fifty, greatly aged and ailing. It was at this time that Velázquez painted his last portrait. The figure of Olivares had not lost its authority, but his presence was less impressive than in the previous portrayals. In an intelligent rapacious face, an expression of tension has appeared; the eyes look more sceptical than assured. Sickly pale and flaccid, with swollen eyelids and a heavy, shapeless nose, Olivares gives the impression of losing faith in his own strength. Velázquez achieved an exceptional virtuosity in the complex characterization of the figure. In his objective approach he struck the perfect balance presenting the Conde-Duque's unappealing appearance and the repulsive facets of his character, while simultaneously conveying his outstanding personality. The brushwork is soft and tactile in tone; the face is painted in a flowing manner with the use of impasto, making it seem massive. The intensity of the black colour of the costume and the whiteness of the delicate translucent collar of impeccable shape are conveyed with the utmost artistry. In its depth and complexity, the characterization in Olivares' portrait is close to the portrait of Cardinal de Borja, which survives in a drawing (Academy of San Fernando, Madrid). That work was made in 1637 when the cardinal was nominated chairman of the Council of Aragón. It is one of Velázquez's best portraits in term of the acuity of the depiction. Furthermore, it is unique as the sole authenticated drawing by the master.

In parallel with his art, Velázquez devoted much time to the fulfilment of his palace duties. In July 1636 he was appointed to

*CARDINAL DE BORJA*. 1637
Pencil on paper. 18.6 x 11.7 cm
Academy of San Fernando, Madrid

*WOMAN AT HER NEEDLEWORK.* Ca 1650
Oil on canvas. 74 x 60 cm
National Gallery of Art, Washington

the post of Gentleman of the Wardrobe. Simultaneously, he was entrusted to look after the artists' works in the Alcázar and to carry out decorative works in Madrid on the occasion of various festivities. Velázquez painted portraits of the nobles, who came from other countries to visit the court at Madrid. In December 1637 the Duchesse de Chevreuse arrived from France fleeing the wrath of Cardinal Richelieu. She was in Madrid until February 1638, and in the January Velázquez painted her portrait (which has not survived). In September 1638 the Infanta María Teresa was born; Francesco d'Este, the Duke of Modena, came for her christening. On 24 October, the Duke of Modena, together with Prince Baltasar Carlos, was made a Knight of the Order of the Golden Fleece. Velázquez painted a portrait of Francesco d'Este, which pleased the sitter enormously. The Duke rewarded the artist with a golden chain. The portrait of the Duke of Modena (1638; Galleria Estense, Modena) in armour, with the Order of the Golden Fleece, is one of those works where the ideal of a flawless personality with a high understanding of honour is expressed, as well as chivalry and nobility.

*The Lady with a Fan* (1638–39; Wallace Collection, London) is one of the most alluring female images in the artist's legacy. It would seem, from the number of portraits attributed to Velázquez's studio, that in the 1630s he employed many assistants, including his son-in-law, Juan Bautista Martínez del Mazo.

One significant figure in Velázquez's circle, Juan de Pareja, arrived in Madrid from Seville around 1630. He was of Moorish descent and in documents he is called *esclavo* (slave). No information exists about his activities during this period and for that reason it is important to note that on 24 August 1638 Pareja, together with

*FRANCESCO I D'ESTE.*
*DUKE OF MODENA.* 1638

Oil on canvas. 69 x 51 cm
Galleria Estense, Modena

Velázquez, served as a witness before a notary at the request of Alonso Cano, who had also come to Madrid from Seville. Although it is believed that Velázquez did not entrust Pareja with the execution of complete paintings, *A Knight of the Order of Santiago* (1630s; Hermitage, St Petersburg) is traditionally attributed to him. It is a composition which repeats the scheme of Velázquez's early state portraits, while the painterly style is typical of the 1630s.

Numerous commissions for portraits of the Spanish royals arrived from ruling families of other countries and, judging by the extant works, Velázquez's assistants produced many of them. On 24 September 1632, for example, Velázquez was paid for

Juan de Pareja
*A KNIGHT OF THE ORDER OF SANTIAGO.* 1630s
The Hermitage, St Petersburg

royal portraits, which were to be sent to Germany. It is presumed that they were the portraits of Philip IV and Isabel of Bourbon, now in the Kunsthistorisches Museum, Vienna. The canvases are ascribed to different periods: the portrait of the King to around 1632, and that of the Queen to around 1637–38; both are ascribed to Velázquez's studio. The portrait of Prince Baltasar Carlos (1639; Kunsthistorisches Museum, Vienna) is also the work of the studio. On 26 June 1639 the Cardinal Infante Ferdinand expressed his thanks to the artist for the portrait of Baltasar Carlos in armour sent to him. In the same year portraits of the Prince, King and Queen were sent to England. All three canvases are in Hampton Court, and although their composition is typically Velázquez's, the studio evidently participated in the working up of the paintings. The state portraits of Philip IV and Conde-Duque de Olivares, acquired for the Hermitage in The Hague at the posthumous auction of the collection of King William II of the Netherlands, date from this period. Today the portrait of Philip IV is still in St Petersburg; the portrait of Conde-Duque de Olivares was transferred to the Pushkin Museum of Fine Arts in Moscow in 1930.

In composition the portrait of Philip IV is close to the portrait of the King attributed to Rubens and dated around 1628–29 (Galleria Durazzo-Pallavicini, Genoa). Philip IV is portrayed in an interior, with a balustrade in the background, against a landscape backdrop. In the Hermitage painting the King looks older – as in his portrayals of the 1630s. A table with a tablecloth and a hat lying on it are inserted into the painting, the latter detail is very characteristic of Velázquez's portraits. A great deal of attention is given to the spatial resolution of the interior, something which also appeared in Velázquez's art after his

114

*THE LADY WITH A FAN.* 1638–39
Oil on canvas. 94.6 x 69.8 cm
The Wallace Collection, London

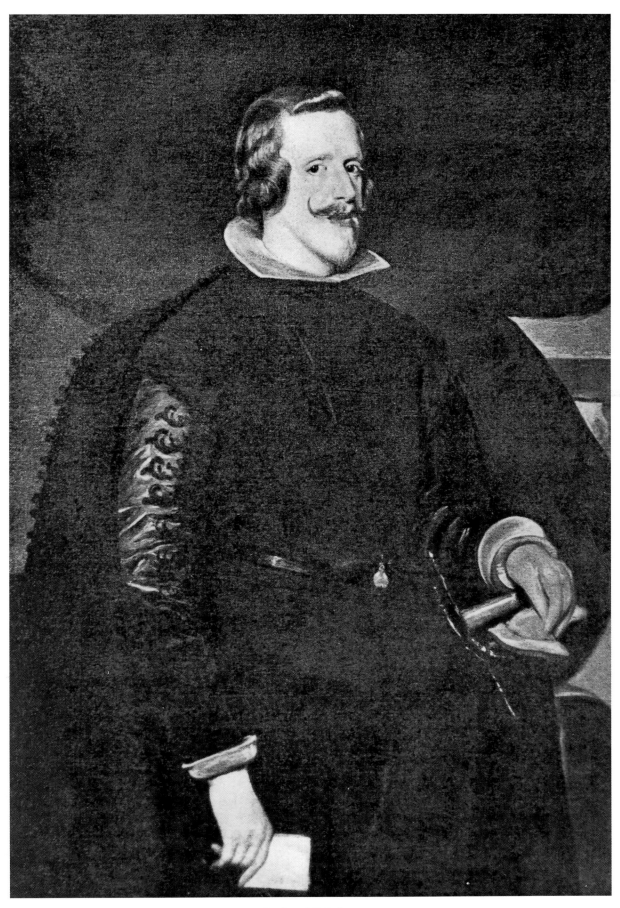

Studio of Velázquez
*PHILIP IV.* Ca 1632
Oil on canvas. 128 x 86.5 cm
Kunsthistorisches Museum, Vienna

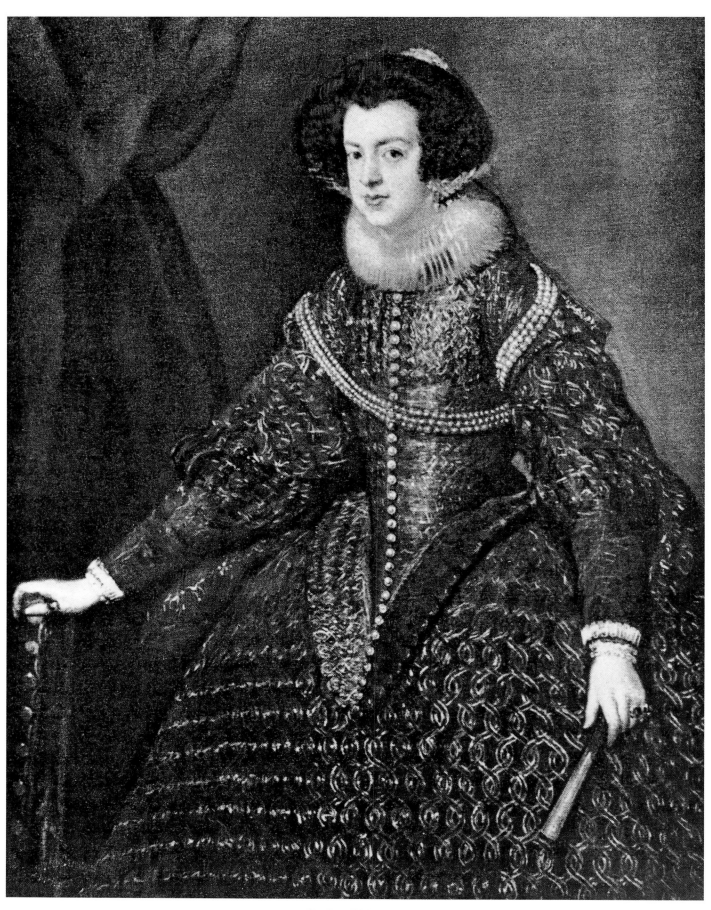

Studio of Velázquez
*QUEEN ISABEL OF BOURBON.* Ca 1637–38
Kunsthistorisches Museum, Vienna

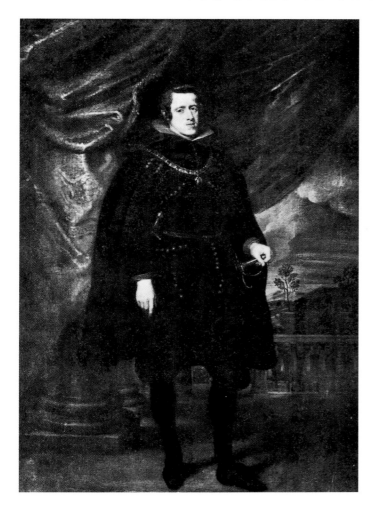

Attributed to Peter Paul Rubens
*PHILIP IV.* 1628–29
Galleria Durazzo-Pallavicini, Genoa

Italian sojourn. It is quite evident that the portrait of Philip IV was made in the studio in the 1630s, though the compositional idea could have belonged to Velázquez.

The portrait of Conde-Duque de Olivares repeats the compositional scheme of portraits in interiors painted in the 1620s. In age, however, Olivares is closer to the half-length portrait of 1638. The richly detailed folds in the tablecloth also reflect the style of the 1630s. In the early nineteenth century the portraits of Philip IV and the Conde-Duque were looked upon as companion pieces: both canvases are of a similar size, the figures are depicted to face each other, and both are set indoors, next to a table with a hat on it.

In the late 1630s Velázquez's fellow-countryman, the talented architect, sculptor and painter, Alonso Cano, joined the artist's circle. He arrived in Madrid from Seville at the beginning of 1638 in order to take up the position of personal artist to Olivares and, one may suppose, that Francisco Pacheco and Velázquez played a major role in his appointment. Cano became friendly with Velázquez; he was twice godfather to the painter's granddaughter and grandson – in October 1638 and in March 1640.

During the fire that took place in the Buen Retiro Palace in 1640, many works perished and many were damaged. Cano was commissioned to restore one hundred and sixty canvases. In addition, together with Velázquez, Cano went to Old Castile in search of works which could be substituted for those that had perished.

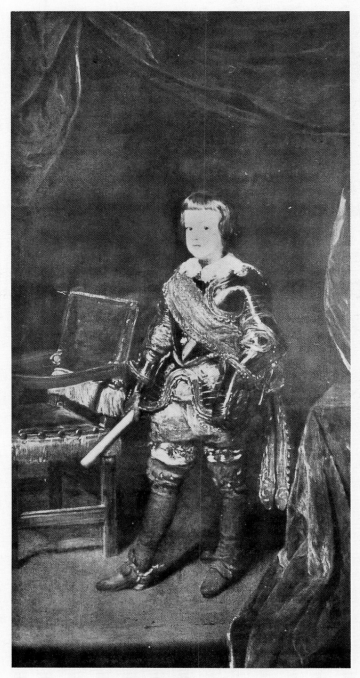

Studio of Velázquez
*PRINCE BALTASAR CARLOS.* 1639
Royal Collection (Hampton Court Palace), England

119

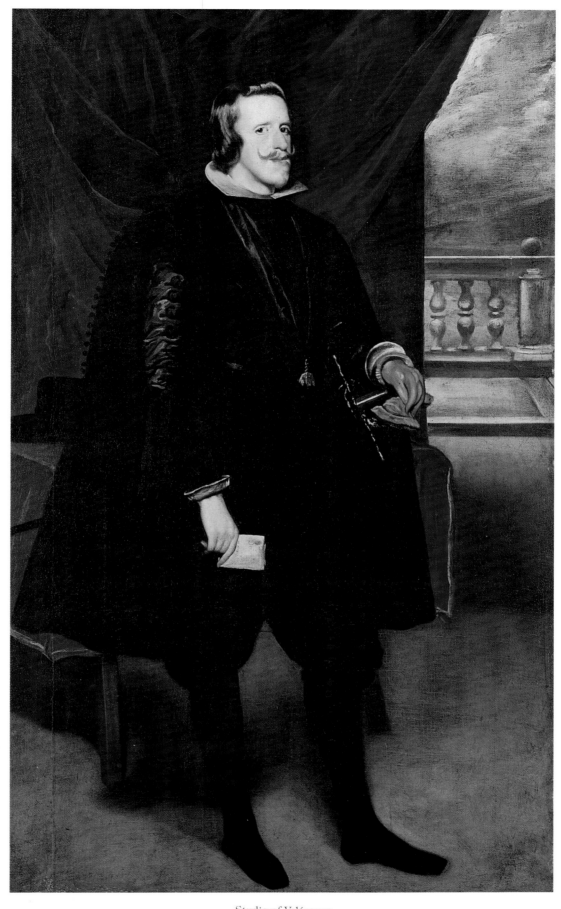

Studio of Velázquez
*PHILIP IV.* Mid-1630s
The Hermitage, St Petersburg

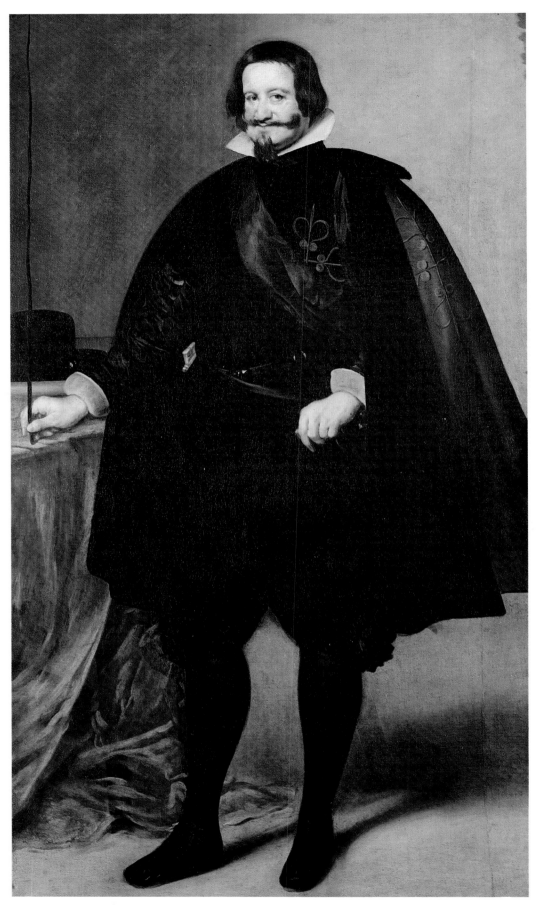

Studio of Velázquez
*CONDE-DUQUE DE OLIVARES.* Mid-1630s

Oil on canvas. 212 x 126 cm
Pushkin Museum of Fine Arts, Moscow

*THE CORONATION OF THE VIRGIN BY THE TRINITY.* 1640–44
Oil on canvas. 176 x 134 cm
Prado Museum, Madrid

We know for certain that Velázquez selected works for the Buen Retiro in Valladolid, but, evidently, the artist also visited other cities, most notably Toledo where much of the work of El Greco was still to be found. From the time of his youth and his period of training with Pacheco, Velázquez knew of El Greco's art, but he could only have become well acquainted with the artist's work after his move to Madrid, as El Greco's paintings adorned the Escorial, Alcázar and the Colegio Doña María de Aragón, and were kept in private collections in the capital. Velázquez could not fail to admire the style of the Toledo virtuoso, who had interacted a great deal with the Venetians, but whose manner differed in its boldness, virtuosity and free brushwork. In Velázquez's day, many of El Greco's late Mannerist canvases appeared strange to those who viewed them. Nonetheless, the art of that great painter would come to constitute one of the main sources which inspired the tremendous freedom in Velázquez's style. In the early 1640s Velázquez painted *The Coronation of the Virgin by the Trinity* (1640–44; Prado Museum), with a composition and treatment of light and colour close to El Greco's works on the same subject. El Greco produced a number of versions of *The Coronation of the Virgin*, but Velázquez's

## THE YEARS 1640–1648

El Greco
*THE CORONATION OF THE VIRGIN.* 1590–1604
Prado Museum, Madrid

work is closest to the Toledo master's painting of 1590–1604, now in the Prado Museum. Velázquez's canvas was intended for the private chapel of the Queen in the Alcázar. Until then the artist had never painted heavenly scenes, and it is not surprising that El Greco, a virtuoso of the genre, should have influenced him. Velázquez positioned the main characters in the same manner as El Greco, and painted the folds in the clothes in a similar fashion. In his composition, as well as in El Greco's, there is a radiant dove at the top and swirling clouds that surround the figures. Although many similarities are discernible in the paintings of the two artists, substantial differences are also present, having their roots in the outlooks of two generations. El Greco's artistic system aimed at making the figures incorporeal, floating in the air. On the other hand, Velázquez's figures are tangible and corporeal, the folds of the clothes emphasizing their three-dimensionality. Angels are barely discernible in El Greco's work; while in Velázquez's composition they are replaced with depictions of real children's heads. Several differences exist in the iconography – with Velázquez the gesture of Mary's hands is different; El Greco depicted the Virgin floating on a half moon (an allusion to the Immaculate Conception), Velázquez removed

Alonso Sánchez Coello
*THE INFANTA ISABEL WITH THE DWARF MAGDALENA RUIZ.*
1585-90
Prado Museum, Madrid

this motif, but it is curious that in the shape of Mary's cloak he preserved a line close to the contour of the half moon. It is possible that during work on *The Coronation of the Virgin by the Trinity*, Velázquez based himself on an engraving of Rubens' painting of the same title.

In 1639 one of the last paintings by the great Flemish master, produced for the Torre de la Parada, *The Judgement of Paris*, arrived in Spain. In 1640 Rubens died. Philip IV, at the suggestion of the Cardinal Infante

Ferdinand, acquired Rubens' collection of paintings. A year later the Cardinal Infante, who had enthusiastically encouraged his brother's passion for collecting works of art, died in Brussels. People who had long influenced Velázquez's destiny were disappearing from his life altogether. On 6 January 1643 he personally received the appointment of Gentleman of the Bedchamber from Olivares. Within ten days, on 17 January 1643, the Conde-Duque was removed from power and sent into exile to the city of Toro where he died in 1645. Velázquez, who was invited to court by Olivares and who had enjoyed his support for many years, was among those who accompanied the disgraced minister into banishment. Francisco Pacheco was buried in Seville on 27 November 1644 only a little while before the death of the Conde-Duque.

The period around the turn of the 1640s saw the continuation of the decoration of the Torre de la Parada. Judging by documents, Velázquez painted figures of jesters and dwarfs for this residence: being of relatively small size these paintings could fit over windows and doors. At the present time there is too little evidence for a positive identification of the works mentioned in the 1701 inventory of the Torre de la Parada. That series could well have included the portraits of Juan de Calabazas, nicknamed Calabazillas, and the dwarfs, Francisco Lezcano, nicknamed "Niño de Vallecas", Sebastián de Morra and Diego de Acedo, nicknamed "El Primo". The portrait of Juan de Calabazas was mistakenly called *El Bobo del Coria* (1639; Prado Museum) until the discovery of documents revealing the canvas's proper title. The jester Calabazillas appeared at court after 1630 as a retainer of the Cardinal Infante Ferdinand; in 1632 he passed into the King's service and died in 1639. His nickname comes from the Spanish word *calabaza*, simultaneously

*THE BUFFOON JUAN DE CALABAZAS, CALLED CALABAZILLAS.* Ca 1639
Oil on canvas. 106 x 83 cm
Prado Museum, Madrid

*THE DWARF FRANCISCO LEZCANO (NIÑO DE VALLECAS).* 1640–44
Oil on canvas. 107 x 83 cm
Prado Museum, Madrid

meaning both "bottle" and "stupid". The bottle on the floor unmistakably points to his nickname. He was not a dwarf, but the artist probably specially seated him on a low bench in order to diminish his height. A foolish smile lingers on Calabazillas' face, as if he were addressing an invisible neighbour – his very expressive gesture captured in the painting. The style of painting, the modelling of the face and the sketchy manner of portraying the fingers are similar to *Menippus*. The virtuoso free brushwork in the lace collar elicits particular attention. The interior of the room is presented in scattered light and the shadows are not sharp, reflecting the influence of the air medium.

Dwarfs are depicted in the other three works: they were an inseparable part of the palace staff and were included in court portraits long before Velázquez. Examples can be found in *The Infanta Isabel with the Dwarf Magdalena Ruiz* (1585–90; Prado Museum) and *The Duchess of Béjar with a Dwarf* (ca 1585; private collection, Madrid) by Alonso Sánchez Coello. The attitude toward dwarfs was a serious one; they were never caricatured, but, nevertheless, their natural defects were always emphasized and contrasted with the main figure. Velázquez's portraits differ in this regard: all the attention is concentrated on the traits of the dwarf's personality. Francisco Lezcano was part of Prince Baltazar Carlos' retinue. He appeared at court in 1634 and died in 1649. In no other painting is the deformity of dwarfs so strongly expressed as in this one. The sickly expression of the face, the half-closed eyes, the open mouth and the head bent to one side leave no doubt as to his condition. The diminutive height is guessed from the short legs, one foot turned towards the viewer; the hands inanely sort the playing cards. The figure is painted against a dark background,

Alonso Sánchez Coello
*THE DUCHESS OF BÉJAR WITH A DWARF.* Ca 1585
Private Collection, Madrid

but to the right a mountainous landscape opens out, and the light falls from the side and from the front, creating an intricate play of reflexes.

The dwarf Sebastián de Morra was in the service of the Cardinal Infante Ferdinand in Flanders. After his death in 1643 Sebastián was sent to Spain where he became a retainer of Prince Baltasar Carlos. The dwarf died in 1649. Morra was mentally well-balanced and intelligent but spiteful – his gaze rivets the viewer in the painting (1643–44; Prado Museum), betraying this fact. The dwarf's legs are excessively foreshortened, his hands seem to be lacking fingers. Morra sits in a corner of a room, the rich red colour of his cloak standing out vividly against the dark background. The light is artificial, but the method of its

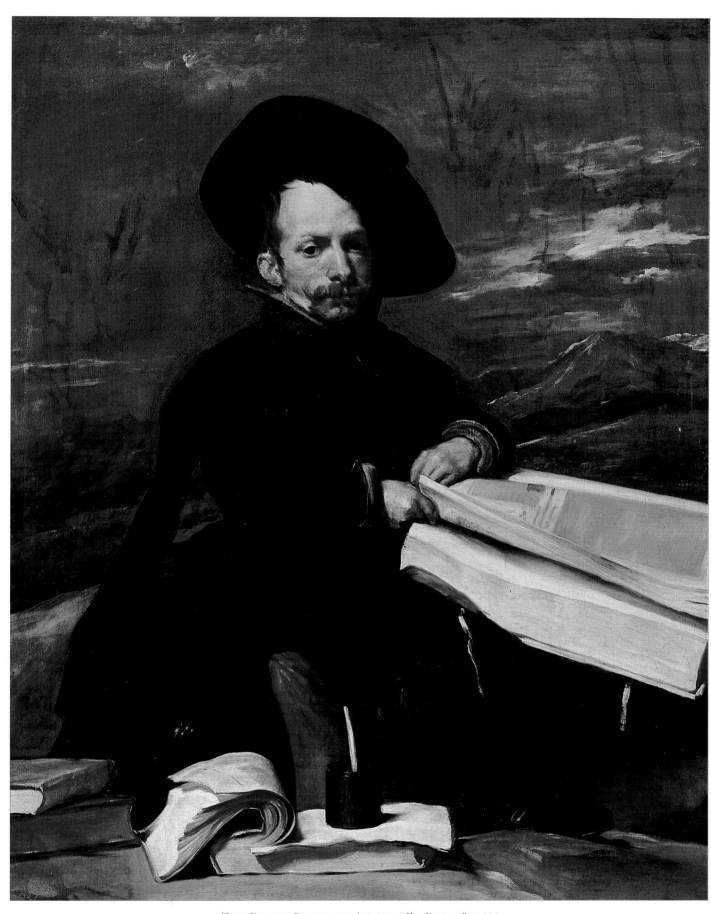

*THE DWARF DIEGO DE ACEDO. "EL PRIMO".* 1644
Oil on canvas. 107 x 82 cm
Prado Museum, Madrid

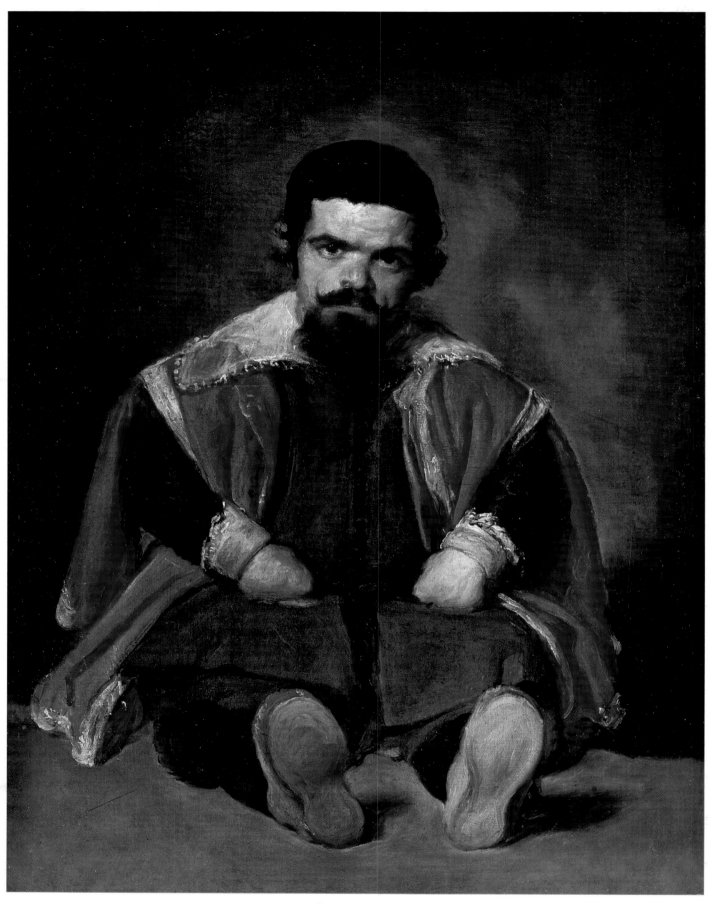

*THE DWARF SEBASTIÁN DE MORRA.* 1643–44
Oil on canvas. 106 x 81 cm
Prado Museum, Madrid

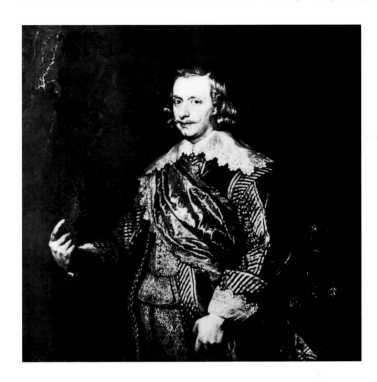

Anthony van Dyke
*THE CARDINAL INFANTE FERDINAND.* 1634
Prado Museum, Madrid

evocation is far removed from the Tenebrist manner, the shadows dissolve in the air medium and light glides along the wall.

The dwarf Diego de Acedo, nicknamed "El Primo", is mentioned in palace documents from 1635. Of noble birth, he was secretary to the King and Keeper of the Seal. In the portrait of 1644 the face of the dwarf is full of dignity. Next to him are his regalia of office. He holds a large folio volume on his knees emphasizing his diminutive size. This portrait was dispatched to Madrid 'in June 1644 from Fraga, when Diego de Acedo accompanied the King during a military campaign.

From 1642 to 1646 Philip IV regularly went to Aragón where he commanded troops fighting the French army which had invaded the territory of Catalonia exploiting an uprising there. In 1644 the King set off to win Lérida back from the French and stopped with the army and a large retinue not far from the village of Fraga. Velázquez, who was supposed to portray the King during the campaign, was also part of the retinue. The King posed in a studio specially built for the occasion. The portrait of Philip IV, which came to be known as *Philip IV at Fraga* (1644; Frick Collection, New York), was sent to the Queen in Madrid at the end of June, and on 10 August, the day of the surrender of Lérida, it was exhibited for general viewing. Evidently, according to the King's wishes, Velázquez painted him in a similar vein to that of the portrait of the Cardinal Infante Ferdinand produced by Van Dyck in 1634 on the occasion of the capture of Nördlingen (in 1636 the work was sent to Spain). Velázquez displayed the genius of a true virtuoso in his depiction of military dress and in his use of an elegant range of red, yellow and white, set off by the black of the hat. The lace collar, the silver pattern of the embroidery on the jacket and the highlights on the sleeves are rendered with light touches of the brush. The speed with which the portrait was created is apparent from the particular freshness and lack of constraint in its execution. This is the final portrait of the King in formal costume which Velázquez painted. The tragic events of the next few years took their toll on Philip IV. In October 1644 the Queen died. In 1646 Philip went to Saragossa with Prince Baltasar Carlos. Velázquez did not accompany them, but Martínez del Mazo, who from 1643 was officially considered to be Painter to the Prince, did. In October the seventeen-year-old Baltasar Carlos fell ill in Saragossa and died.

These dramatic occurrences did not, however, deflect the King's interest from the decoration of the palace. The reconstruction of the Alcázar, in which Velázquez participated, continued. In 1647 he was appointed Inspector of Works, taking place in the octagonal hall, which was intended to house canvases by Rubens and Van Dyck and bronze statues. (The hall was almost

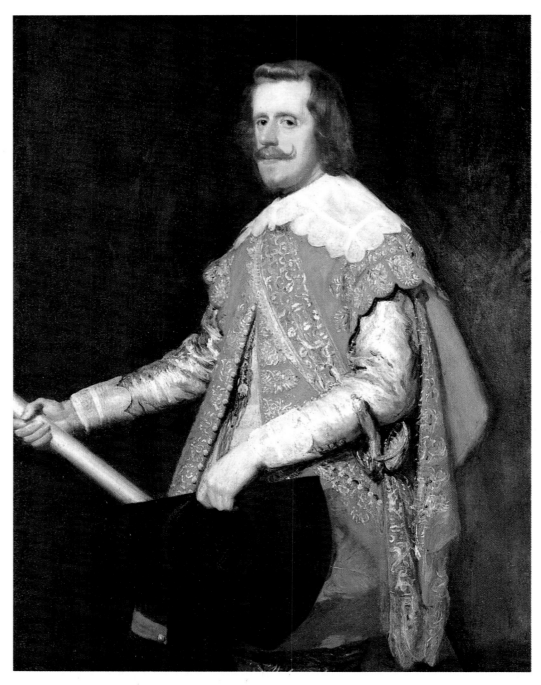

*PHILIP IV AT FRAGA.* 1644
Oil on canvas. 135 x 98 cm
Frick Collection, New York

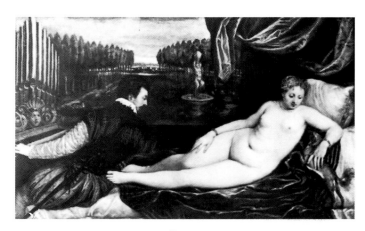

Titian
*VENUS WITH CUPID AND MUSIC*
Prado Museum, Madrid

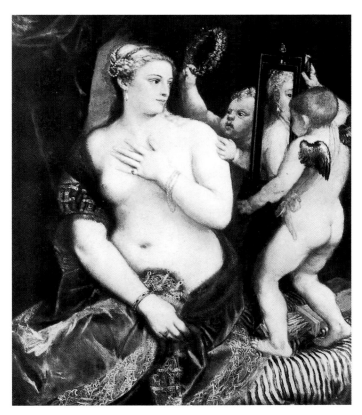

Titian
*VENUS WITH A MIRROR.* Ca 1552–55
National Gallery of Art, Washington

completely destroyed during the fire of 1734.) The New Hall (*Salón Nuevo*) was re-decorated and soon became known as the Hall of Mirrors (*Salón de los Espejos*). Not satisfied with the number of paintings and sculptures, Philip IV acquired more and more works. Velázquez was instructed to make another journey to Italy for that purpose. Before his departure, though, the artist completed yet another painting which is considered to be one of his principal masterpieces – *The Toilet of Venus* (ca 1648; National Gallery, London).

Spanish artists rarely painted female nudes. That was something dictated by their inherent piety and by ecclesiastical prohibitions. In neighbouring Italy at the time of the Renaissance, however, the most inspired and outstanding canvases featured Venus, the goddess of love. The King of Spain and Holy Roman Emperor, Charles V, known for the broad scope of his views and interests, highly valued Titian's art: he ordered portraits from the artist and commissioned him to paint *Venus with Cupid and Music* (Prado Museum). It was meant for Prince Philip, the future King Philip II, who inherited his father's love for Titian and a passion for collecting. It is remarkable that it was to commissions from Philip II, during the period of the harshest Inquisitional terror, that Titian painted almost all his works on mythological subjects. (To distinguish them from his portraits and religious works, such paintings were called *poesie*.)

Philip IV, striving to imitate his great-grandfather and grandfather in all things, was primarily successful as a patron of the arts and a collector. During his reign paintings on mythological subjects were commissioned from Rubens. The period of construction and decoration of the Buen Retiro and Torre de la Parada coincided with the height of interest in classical themes and the depiction of the female nudes. In 1639 all Titian's

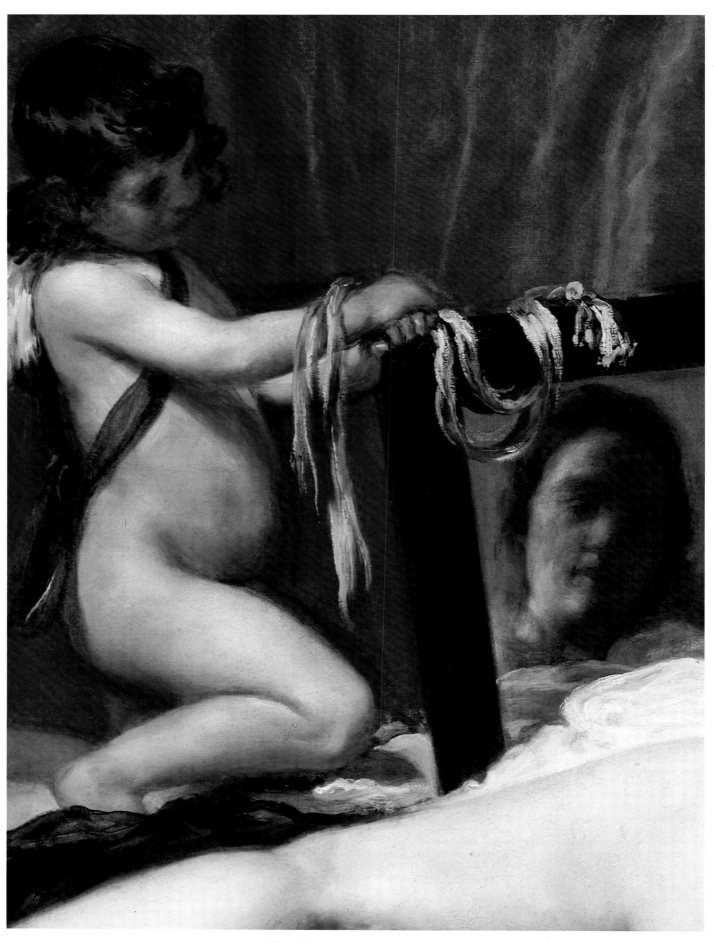

*THE TOILET OF VENUS.* Detail

*poesie* were brought to Alcázar. Many of Rubens' canvases were also assembled there. Velázquez supervised the artistic aspect of the interior decoration of the palace and was thoroughly acquainted with these paintings. Although he had no predecessors among his fellow-countrymen, in creating *The Toilet of Venus* (as well as other similar works which have not survived to the present day), he followed the Italian tradition. Arthur Hopton, the British ambassador at the Spanish court, remarked that the aristocracy imitated Philip IV's passion for art, and identified Luis de Haro among others as an avid collector. That noble was Olivares' nephew and, after the death of the Conde-Duque in 1645, he inherited all his titles, as well as the post of Prime Minister. Both Don Luis and his son, Gaspar de Haro, the Marquis de Heliche, valued Velázquez's work. In the inventory of the Marquis de Heliche's property, dated June 1651, *The Toilet of Venus* is mentioned for the first time. As the artist was absent from Madrid from November 1648 to June 1652, it must be supposed that he painted the work before his departure.

In *The Toilet of Venus* Velázquez brought together motifs of two of Titian's works – *Venus with Cupid and Music* and *Venus with a Mirror*, painted at the order of Philip II. For all that the Spanish master created a unique work in world painting, depicting Venus from the back. Her lissom and slender body, like the gesture of her hand and her coiffure, preserve the spontaneity of a direct observation, and the charming sweet face, reflected in the mirror, in no way puts one in mind of classical goddesses. The treatment of Venus by Velázquez is very chaste, revealing both admiration for the beauty of the female body and the psychology of the court, where paintings of nudes in the King's apartments were covered when the Queen walked through. Velázquez's work contrasts with Titian's *Venus with Cupid and Music* through its greater intimacy. Venus is shown not in a landscape, but in an alcove; beside her is her child – Cupid who is gazing at the reflection in the mirror. Even such a detail as the pink ribbon tossed over the frame of the mirror and Cupid's hand, imparts an atmosphere of cosiness to the portrayal. At the same time the work is classically elevated. The composition is based on a quiet, measured rhythm. The semicircular line of Venus' body is repeated in the design of the bedcover and sheet, forming an impression of serenity and harmony. The showy curtain brings a note of elation and solemnity. In the combination of nakedness and chastity, intimacy and loftiness, ease and formality, *The Toilet of Venus* possesses no equals. Goya felt the powerful impact of this work. In his day it belonged to the influential statesman Manuel Godoy and decorated a special "cabinet" which housed other depictions of "Venus at rest". At the order of that minister Goya painted *Naked Maja* for the same room, borrowing from Velázquez the idea of incarnating the national ideal of beauty.

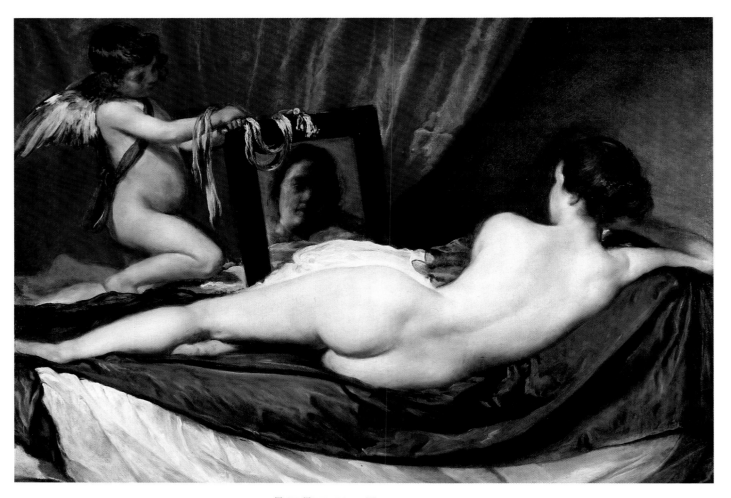

*THE TOILET OF VENUS.* Ca 1648
Oil on canvas. 122.7 x 177 cm
National Gallery, London

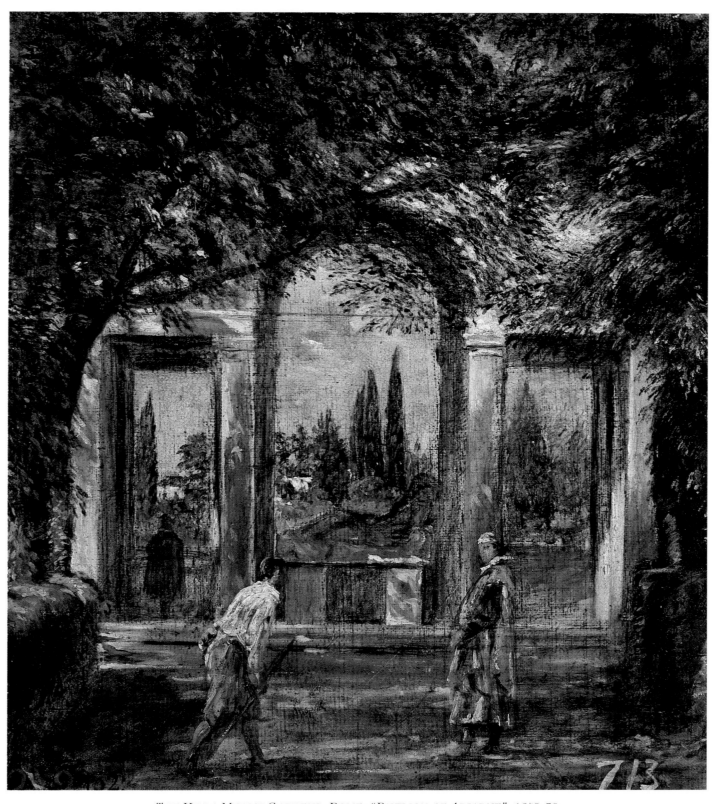

*THE VILLA MEDICI GARDENS, ROME: "PAVILION OF ARIADNE".* 1649–50
Oil on canvas. 43 x 38 cm
Prado Museum, Madrid

136

In November 1648 Velázquez left Madrid and on 7 December he arrived in Málaga. He left for Italy with the Duque de Maqueda y de Nájera and his retinue, to meet the new bride of Philip IV, the King's own niece Mariana of Austria. The ship sailed from Málaga on 21 January 1649 and moored in Genoa on 11 March. Velázquez continued on his way, via Milan and Padua, to Venice. The Spanish ambassador in Venice, the Marquis de la Fuente, received him and did everything to show his guest as many works of art as possible. Velázquez did not stay long in Venice: on 24 April he was already in Rome where he was to select classical statues from which to make casts (several of them were cast in bronze). One of the best collections of antiquities was to be found at the Villa Medici, with which Velázquez was well acquainted from his stay in Rome in 1629–30. He painted two landscapes featuring the villa – *The Villa Medici Gardens, Rome: "Pavilion of Ariadne"* and *The Villa Medici Gardens, Rome: Grotto-Loggia Façade* (1649–50; Prado Museum). For a long time it was thought that these works were painted at the time of Velázquez's first visit to Rome, as two landscapes were listed among the works he brought back with him then. The dating of these works to around 1630 raised

## THE SECOND ITALIAN JOURNEY 1649–1651

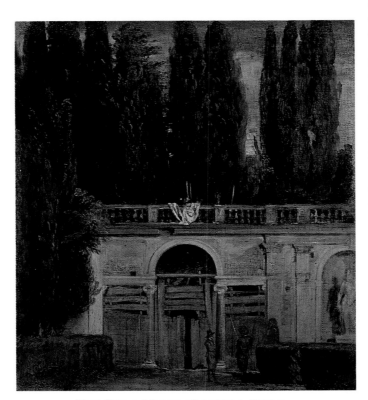

*THE VILLA MEDICI GARDENS, ROME: GROTTO-LOGGIA FAÇADE.* 1649–50
Oil on canvas. 48 x 42 cm
Prado Museum, Madrid

doubts since Velázquez's skill as a landscape painter matured only from the mid-1630s when he created works for the Buen Retiro. On the other hand, the views of the Villa Medici are by a virtuoso master, and it was recently ascertained that the landscapes do indeed date from his second Italian visit. In 1648 and 1649, it emerges, repair work was underway at the Villa Medici and this can be seen in the painting *The Villa Medici Gardens, Rome: Grotto-Loggia Façade*. Many painters residing in Rome in the seventeenth century were interested in landscapes, Dutch and French artists above all, but they used their observations of nature in order to complete their compositions in the studio. Claude Lorrain made sketches in the open air. No one, however, apart from Velázquez, created paintings wholly outdoors. In the seven-teenth century the Spanish artist succeeded in achieving the goal the Impressionists set themselves in the second half of the nineteenth century – he depicted the movement of leaves, the sun's rays visible through them and the play of patches of light on the road. Velázquez discovered for himself the secret of the influence of air and light on figures and objects: in his landscapes they merged with the surrounding setting. One of the main masterpieces Velázquez

El Greco
*CARDINAL FERNANDO NIÑO DE GUEVARA.*
Ca 1600
Metropolitan Museum of Art, New York

Titian
*POPE PAUL III.* 1543
Gallerie Nazionali di Capodimonte, Naples

produced in Rome is the portrait of Pope Innocent X (1650; Galleria Doria-Pamphili, Rome). From 1626 to 1630 Giovanni Battista Pamphili, later to become Pope Innocent X, was the Papal Nuncio in Madrid and it is quite possible that he was acquainted with Velázquez at that time. Now the artist was accorded a great honour – to paint a portrait of the Pope.

Over the course of a century three closely interconnected masterpieces appeared in Western European art: Titian's portrait of Pope Paul III, El Greco's portrait of Cardinal Fernando Niño de Guevara and Velázquez's portrait of Pope Innocent X. Titian was the first to sharpen the characterization in portraying the head of the Church. El Greco brought it to a symbolic level – the conception of the figure in his portrait was prompted not only by a real-life impression, but also by a yearning to incarnate the idea of a redoubtable Church Militant. Velázquez was closer to Titian in his conception of the spontaneous perception, but he portrayed the Pope not in one particular mental state or another, but as a strong and many-sided character. From the face of Innocent X one can deduce different strains of his personality, but no single aspect dominates: the characterization of the Pope is integral and objective. The representational side of the work is very impressive. The back of the armchair frames the figure, focusing attention upon the sitter and bringing a note of serenity and harmony. The powerful resonance of red in the portrait could have appeared under the influence of El Greco's portrait of Cardinal Niño de Guevara. But Velázquez's red reverberates with still more sonority due to the curtain. His portrait of Innocent X is a brilliant culmination to the line of portraits of senior Church figures, begun by Titian and continued by El Greco. Innocent X, pleased with the portrait, rewarded the artist with a gold chain and

*POPE INNOCENT X.* 1650
Oil on canvas. 140 x 120 cm
Galleria Doria-Pamphili, Rome

Studio of Velázquez
*CARDINAL CAMILLO ASTALLI.*
*KNOWN AS CARDINAL PAMPHILI.* 1650
Art Museum, Krasnodar

medal bearing his own likeness. In turn, Velázquez asked the Pope to petition for his initiation into one of the military orders, which was done immediately.

Concurrently with the portrait of Pope Innocent X, Velázquez painted a picture of his assistant, Juan de Pareja (1650; Metropolitan Museum of Art, New York). Although Pareja was a slave, the most striking feature of the portrait is the strong feeling of dignity which it exudes. The texture of Pareja's face and clothing is very powerful and the brushwork is energetic and decisive.

The artists of Rome recognized Velázquez as one of the best contemporary painters. In January 1650 he was made a member of the Academy of Saint Luke, and on 13 February he was admitted into the *Congregazione dei Virtuosi*, an association of artists which each year arranged exhibitions of the most outstanding works in the portico of the Pantheon. In March 1650 Velázquez exhibited the portrait of Juan de Pareja there (on 23 November 1659 a document releasing him from slavery was drawn up in Rome). Velázquez produced many portraits of figures in the Pope's entourage, but far from all of them have survived or been identified. Camillo Astalli Pamphili, the adopted nephew of Innocent X, received the name Pamphili from him and the right to a hereditary coat of arms. In 1650, to the surprise of the whole of Rome, Astalli Pamphili was elevated to the rank of cardinal. Evidently in connection with this appointment, Velázquez painted his portrait (1650; Hispanic Society of America, New York), which is very expressive and far lighter in manner of execution than the portrait of Juan de Pareja. At that time too Giuseppe Testano made an engraving, not from this work, but from another, oval, portrait of Pamphili, later to become part of Gaspar de Haro's collection. The oval work was long believed to be lost, but has now been identified as the canvas acquired for the Hermitage in 1835 by the Russian consul in Cádiz, Alexander Gessler, as a work by Mateo Cerezo. Judging by its style, that portrait was painted not by Velázquez himself, but in his studio (in 1930 the oval portrait was transferred from the Hermitage to the Art Museum in Krasnodar). This period also gave us a portrait of Monsignor Camillo Massimi (The National Trust, Bankes Collection, Kingston Lacy, England), Pope Innocent X's close confidant. He was a collector, patron of the arts and connoisseur of antiquity, who evidently advised Velázquez. (Later, in 1654, Massimi was Papal Nuncio in Madrid and maintained friendly relations with the artist).

*CARDINAL CAMILLO ASTALLI, KNOWN AS CARDINAL PAMPHILI.* 1650
Oil on canvas. 61 x 48,5 cm
The Hispanic Society of America, New York

*JUAN DE PAREJA.* 1650
Oil on canvas. 81.3 x 69.9 cm
Metropolitan Museum of Art, New York

*MONSIGNOR CAMILLO MASSIMI*
Oil on canvas. 74.5 x 59.5 cm
The National Trust, Bankes Collection, Kingston Lacy, England

143

*QUEEN MARIANA OF AUSTRIA. 1652–53*
Oil on canvas. 209 x 125 cm
Prado Museum, Madrid

The new Queen – Mariana of Austria – arrived in Spain in 1649. She was only four years older than her cousin María Teresa, Philip IV's daughter from his first marriage, and the two bore a striking resemblance to each other. On 12 July 1651, immediately after Velázquez's return, the Infanta Margarita was born as the King's first daughter from his second marriage. The Queen and the King's two daughters became the principal models for Velázquez and his studio in the 1650s. In November 1652 Velázquez was appointed to the post of chief Chamberlain of the Imperial Palace. The King gave preference to his favourite painter over several other candidates. On the one hand, it was a great honour, but on the other, this appointment left him very little time for his art. The main demand the post imposed on Velázquez as an artist was the depiction of important personalities in the diplomatic arena. One of the first portraits Velázquez produced after his arrival was of Mariana of Austria (1652–53; Prado Museum). Her image is treated with solemnity. A clock stands on the table. An element of palace decoration, it is at the same time a *vanitas* – a reminder of the transience of earthly existence – and an allusion to the general atmosphere at court where the ageing King set the tone: Philip had become disillusioned,

## THE FINAL DECADE 1651–1660

Unknown artist of the 17th century
*THE ALCÁZAR IN MADRID*
Museo Municipal, Madrid

had experienced personal tragedies and was now drawn increasingly towards religion. In the 1650s fashions changed, becoming more fanciful and pretentious. Hooped skirts (*guarda-infantas*), elaborate coiffures, adorned with ribbons and bows, which echoed the shapes of the wide skirts, and an abundance of decor on the dress led to a new aesthetic in portraiture. A similar fashion had existed in Spain at the beginning of the century. At that time, Spanish artists, notably Bartolomé González, introduced a stylization of costume, reducing it to almost geometrical forms. Velázquez revived this tradition. The difference lay in the fact that artists at the beginning of the century used drawings, but Velázquez turned exclusively to the medium of painting. The texture of the fabric and the wealth of the decor are rendered in an Impressionistic manner with separate dabs of paint, which at a distance transform themselves into an enchanting image. At the same time as the Queen's portrait, Velázquez also produced a portrait of the Infanta María Teresa (1652–53; Kunsthistorisches Museum, Vienna) intended for dispatch to Vienna in February 1653.

In the absence of a male heir to the Spanish throne, María Teresa, Philip IV's elder daughter, was regarded at other courts as one of Europe's most eligible brides.

Bartolomé González y Serrano
*PORTRAIT OF MARGARITA ALDOBRANDINI.*
*DUCHESS OF PARMA.* 1610s
The Hermitage, St Petersburg

Portraits of her were sent to different countries. As in the portrait of Mariana of Austria, a stylized pose and gesture mingle here with an unusual freedom of painterly manner.

The Infanta Margarita became Velázquez's most engaging model. The delightful girl, blonde and blue-eyed, immediately charmed the artist, and inspired him to create a number of masterpieces. The portrait of the Infanta Margarita in a pink dress (*ca* 1653; Kunsthistorisches Museum, Vienna) was also destined for Austria. Next to the two-year-old girl stands a table with a vase of flowers. This superbly painted detail, never before encountered in Velázquez's portraits,

possesses profound significance. The bouquet not only conjures up the analogy of the girl and a flower, not only instills a poetic mood in the painting, but is also associated with the theme of *vanitas* – the ephemerality of life, the inevitability of decay. The colour scheme is based on a harmony of blue, red and pink tones. The silver pattern on the child's pink dress echoes the blue colour of the curtain and tablecloth, while the pink flowers in the glass vase reverberate with the hues of her dress. The lightness of the artist's brush, the variety of methods of applying paints and the masterly skill in the evocation of the textures of the carpet, silk and lace demonstrate the attainment of the highest degree of virtuosity.

From infancy, the Infanta Margarita was intended to become the wife of Emperor Leopold I, and for that reason her portraits were regularly sent to the Austrian court. The portrait of the Infanta Margarita in a white dress (Kunsthistorisches Museum, Vienna) dates from 1655–56. At that time she was about five years old. She definitely looks older than in the previous portrait: her curly locks fall freely on her shoulders and she wears a white dress decorated with silver embroidery. Only the soft accents of the red ribbons enliven the refined light palette.

At the age of eight, Margarita was portrayed in a pale blue dress (1659; Kunsthistorisches Museum, Vienna). The pose and the accessories of the furnishings are already those found in depictions of grown women. A large clock stands on the table (the painting has been cut down, and this detail is now only partly visible). The range of blue, rarely used by the artist, is especially attractive. The golden chain and large brown fur muff intensify the impression of grandeur. The pattern of the dress is reduced to stripes and triangles. Portraits of the Infanta were often painted in the artist's studio, probably, with some involvement on his part.

146

*THE INFANTA MARÍA TERESA.* 1652–53
Oil on canvas. 127 x 99 cm
Kunsthistorisches Museum, Vienna

*THE INFANTA MARGARITA IN PINK.* Detail

*THE INFANTA MARGARITA IN PINK.* Ca 1653
Oil on canvas. 128 x 100 cm
Kunsthistorisches Museum, Vienna

*PHILIP IV.* Ca 1654
Oil on canvas. 69 x 56 cm
Prado Museum, Madrid

Diego Velázquez and his studio
*THE INFANTA MARGARITA*
Oil on canvas. 80 x 62.5 cm
Museum of Western and Oriental Art, Kiev

*PRINCE PHILIP PROSPER.* Detail

*PRINCE PHILIP PROSPER.* 1659
Oil on canvas. 128.5 x 99.5 cm
Kunsthistorisches Museum, Vienna

Numerous examples have survived, including the portrait in the Museum of Western and Oriental Art in Kiev, which is similar to one in the Prado Museum.

In 1659, together with the portrait of the Infanta Margarita in a pale blue dress, a portrait of Prince Philip Prosper (1659; Kunsthistorisches Museum, Vienna) was sent to Austria. He was born in 1657, but destined to live for only four years. The child's feeble sickliness is reflected in the portrait. The artist painted the only male heir to the throne in opulent royal apartments, yet at the same time endowed the work with a feeling of intimacy and cosiness. The soft rug on the floor, the velvet cushion with the cloth carelessly thrown over it and especially the charming little dog, lounging freely in the armchair in the foreground, disperse the solemn atmosphere which the palatial setting could have evoked.

The portraits of Philip IV painted in the 1650s were more half-portraits than official ones. The portrait of the King in the Prado Museum, of which Pedro de Villafranca made an engraving, dates from 1654. In the whole of art, and especially in the seventeenth century, the Baroque era, it is difficult to find a similar treatment of a king, recalling more the portrayal of an ecclesiastic than a ruler. In the portrait of Philip IV (ca 1656; National Gallery, London), also engraved by Villafranca, the Order of the Golden Fleece is included but, in essence, the treatment of the image remains unchanged. In these works the character and mood of Philip IV are most fully expressed – his exalted sense of royal dignity, his disenchantment, his inclination to reflection, phlegmatism and weak will. A fine variant of the London portrait, attributed to Velázquez's studio, is now in the Hermitage.

During his later years Philip IV did not lose his interest in art, but, if earlier he concentrated on the decoration of the residences intended for rest and entertainment, he now turned his attention to the Escorial. He spent more and more time there, giving himself up to religion and meditation. The construction of the Pantheon, which had dragged on for many years, was finally completed. Philip IV decided to re-decorate the sacristy of the cathedral and the hall of the Capítulo. Velázquez worked on this project and collected the best religious canvases by Italian and Flemish masters for the decoration of the Escorial, transforming the place into a veritable museum. Concurrently he decorated the Alcázar in Madrid, which amazed contemporaries with its profusion of works of art. In 1656 Velázquez painted the famous work – *Las Meninas* (*The Maids of Honour*) (Prado Museum). Detailed information concerning it, as well as the date of its creation, has been left us by Antonio Palomino, who arrived in Madrid in 1678, became a court artist under Charles II and was well acquainted with people who had known Velázquez. Palomino named all the figures in the work and stated that the painting was set in Velázquez's studio.

Different opinions have been put forward regarding the narrative content of *Las Meninas*. According to one of them, the Infanta Margarita accompanied by her retinue enters the artist's studio in order to look at the portrait which he is painting. On the opposite side the King and Queen appear; they are reflected in the mirror, the eyes of several of those present are focused upon them. As for the large canvas standing on the easel in front of the artist, the suggestion has been put forward that it is *Las Meninas*. In the centre of the composition is the Infanta Margarita; she is five years old and her appearance is very similar to that captured in the portrait, sent to Vienna, where she is wearing a white dress. To the left the young maid of honour, María Agustina Sarmiento, is offering her a drink of water.

*PHILIP IV.* Ca 1656
Oil on canvas. 64 x 53.7 cm
National Gallery, London

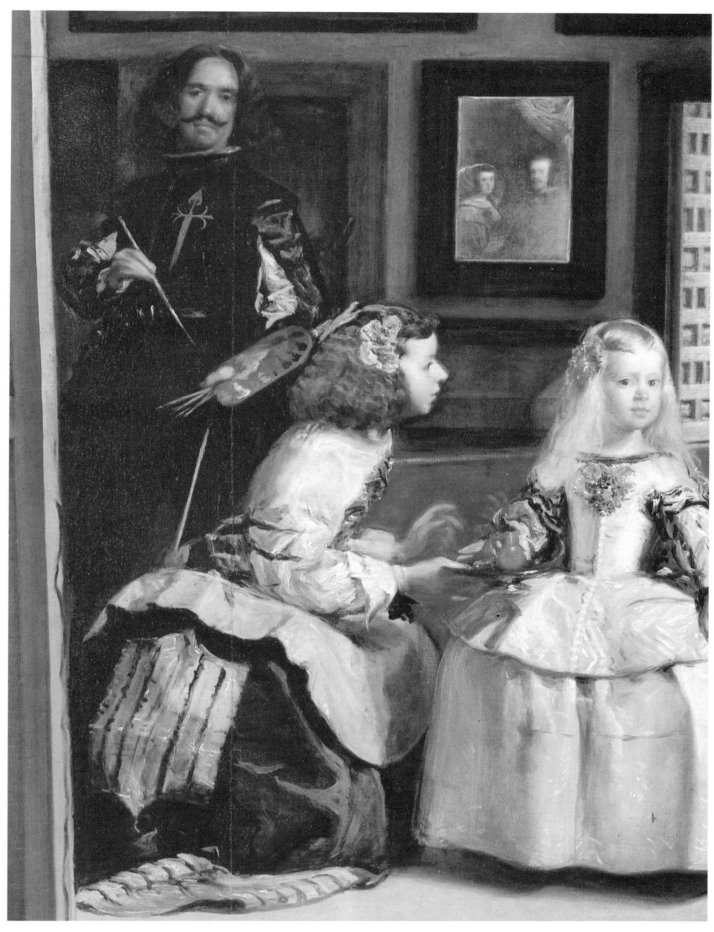

*LAS MENINAS.* Detail

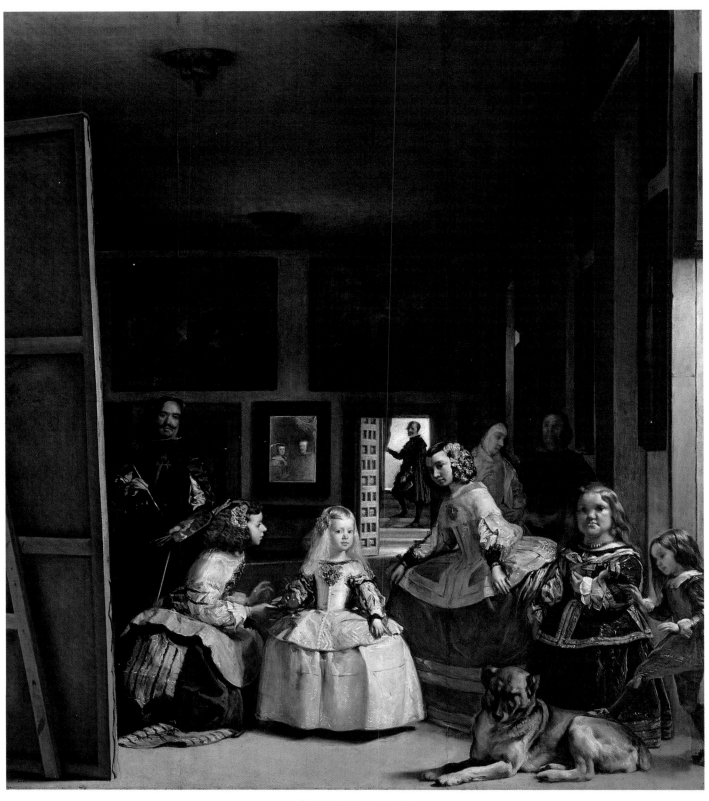

*LAS MENINAS.* 1656
Oil on canvas. 318 x 276 cm
Prado Museum, Madrid

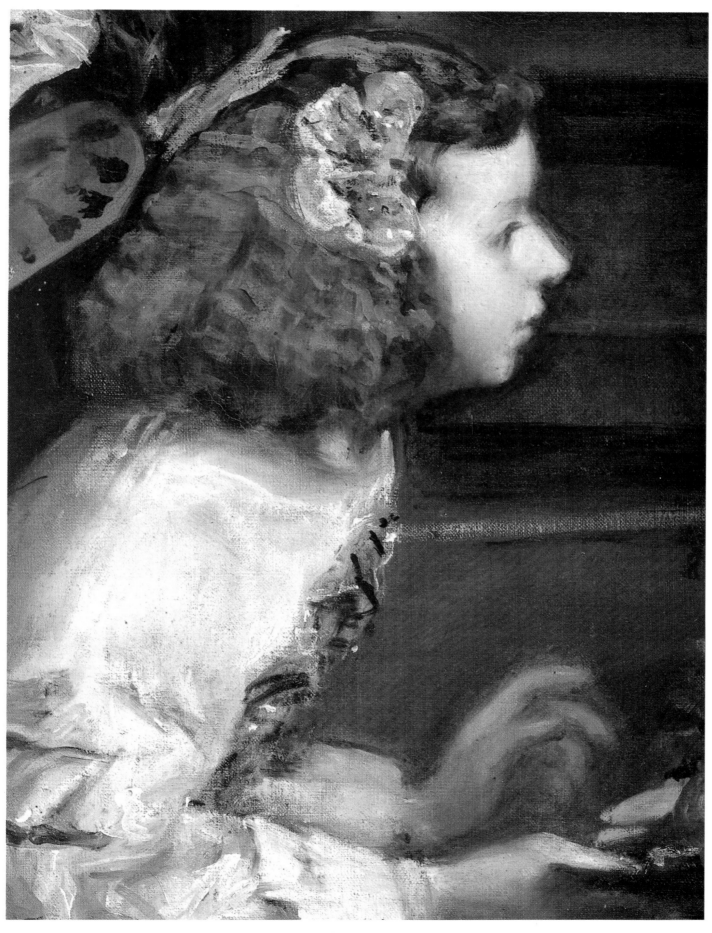

*LAS MENINAS.* Detail

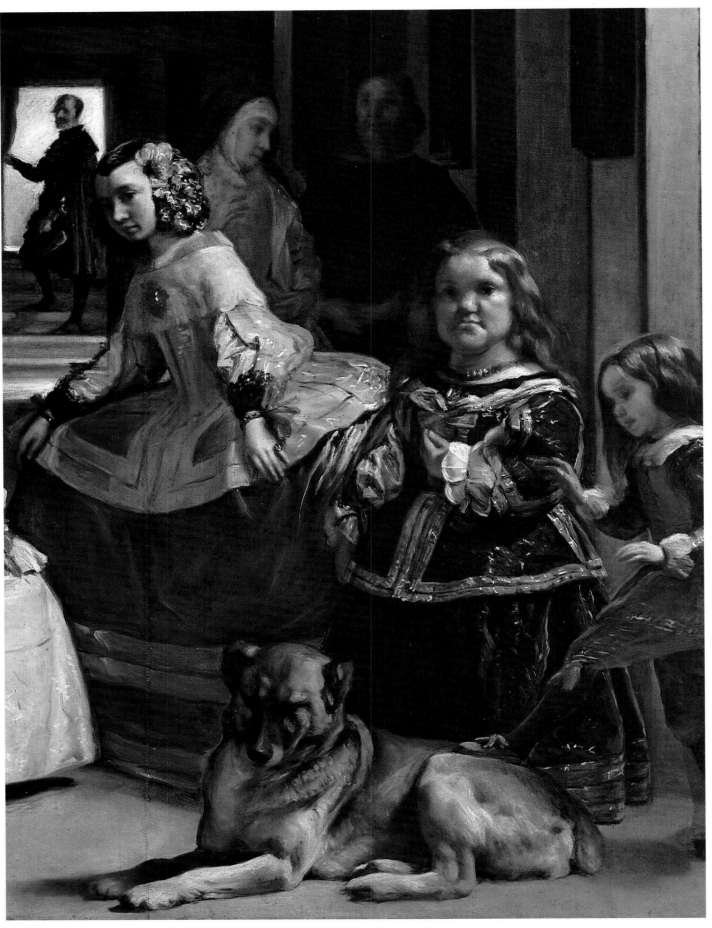

*LAS MENINAS.* Detail

To the right the maid of honour, Isabel de Velasco, is making a curtsey. Velázquez with palette and brush in hand is standing at the easel. In the doorway in the background is Joseph Nieto, the Queen's Chamberlain. Behind Isabel de Velasko is Doña Marcela de Ulloa, a lady of the court, who is talking with a courtier whom Palomino did not name, but stated that he was a "guardian of women". A dog lies in the foreground; the dwarf, Nicolasito Pertusato, is kicking it; next to him is Mari Bárbola, "a dwarf of terrible appearance", as Palomino writes. The most striking aspect of this work is the combination of the palace entourage and court etiquette with an ordinary, down-to-earth casualness. Velázquez consciously strove to capture the evanescent, unexpected moment, and at the same time, the typical daily round of the royal family.

Velázquez's self-portrait occupies a special place in the painting. The action takes place in the artist's studio set up in the Alcázar where Prince Baltasar Carlos' apartments had once been. The walls are hung with paintings – copies by Martínez del Mazo of Flemish works for the Torre de la Parada on subjects from classical mythology. The King often visited the studio to watch Velázquez at work and to discuss questions relating to the decoration of the residences with him. The artist lived more than thirty years in close proximity to Philip IV. The inclusion of his self-portrait in the work depicting the royal family, indicates his awareness of the high social position that his talent had earned him. When Velázquez painted this work he had not yet been made a Knight of the Order of Santiago. When that honour was conferred on him, he added its distinctive red badge to his costume in the painting. According to Palomino, the King himself undertook that task.

One of the main problems in seventeenth-century painting was the rendering of space, a concern of Velázquez's from the early years of his career. His development in this field reached a brilliant culmination in *Las Meninas*. The spacious palatial apartments are brought into correlation with the scale of the figures; this is particularly emphasized by the large size of the canvas before which stands the artist. The sense of depth is attained by the foreshortening of the side wall and the pictures hanging on it, by the gradual diminishing of the size of the figures and by the light from the open door in the background. But this is not sufficient for the artist. He compels the viewer to also apprehend the space in front of his easel, which is beyond the confines of the picture. The King and Queen, whose presence in the studio remains invisible, are reflected in the mirror. In one of his earliest paintings, *Luncheon*, the artist placed a knife at the edge of the table, as if it were possible for the viewer to grasp it, in an attempt to expand the frames of the canvas. Many years passed before he moved away from the naive Caravaggist method to his own extremely complex system of conveying space. Palomino recounts that when Luca Giordano arrived at the Spanish court at the end of the seventeenth century, King Charles II showed him *Las Meninas* and asked him his opinion of the work. The Italian artist declared it to be "the theology of painting" (at a time when theology was reckoned above all other sciences). Philip IV kept Velázquez's masterpiece in his study.

In the second half of the 1650s, Velázquez created yet another of his masterpieces, *The Fable of Arachne* (traditionally known as *The Spinners*; 1656–58; Prado Museum). The collector Pedro de Arce commissioned the work, and it is first mentioned in the inventory of his possessions made in 1664. Since other earlier inventories, including that of 1657, do not mention the picture, it can be assumed that the artist painted

*THE INFANTA MARGARITA IN BLUE.* 1659
Oil on canvas. 125.5 x 107.5 cm
Kunsthistorisches Museum, Vienna

it roughly between 1656 and 1658. The subject was taken from Ovid's *Metamorphoses*. The young mortal Arachne attained such skill in weaving that she boasted of having surpassed even the goddess Minerva, the protector of spinners and weavers. Hearing of this impertinence, Minerva appeared in the guise of an old woman and tried to persuade Arachne to moderate her claims, but the woman persisted. Reverting to her true form, Minerva challenged Arachne and wove a cloth, which glorified the gods headed by Jupiter and had around its edges depictions of mortals, punished for their impertinence in competing with the gods. For her work Arachne selected those episodes in which Jupiter by means of metamorphoses seduced mortal women. Both cloths were superb, evoking equal praise among those who witnessed the contest. However, Arachne's success enraged Minerva so much that she tore her rival's work to pieces. After that the goddess struck Arachne three times with a shuttle on the forehead. The woman, overcome by the goddess's wrath, hanged herself, but Minerva spared her from death and transformed her into a spider, compelled to eternally make cobwebs and hang from them. Rubens also used this story, selecting the moment of Arachne's punishment for her work. Velázquez painted the scene in his own way. Evidently, he chose not move away from Ovid's text in which Minerva, the goddess, competes with Arachne and showed Minerva as an elderly woman, in the way she first appeared before her rival. This provided the opportunity to paint a real workshop in the foreground, evidently the St Isabel manufactory. The women are busy working. The artist admires the natural grace of their poses and the measured rhythm of their movements. In the semi-darkness of the room, the stuffiness can be felt and a scattered light glides over the figures.

*THE FABLE OF ARACHNE (THE SPINNERS)*. 1656–58
Oil on canvas. 167 x 250 cm
Prado Museum, Madrid

*THE FABLE OF ARACHNE (THE SPINNERS).* Detail

*THE FABLE OF ARACHNE (THE SPINNERS)*. Detail

165

The artist captures the rapid turning of the wheel when the spokes cannot be discerned. The scene is so expressive that the work was given another title, *The Spinners*. The second episode is depicted in the background. Here Minerva has already become the mighty goddess, while Arachne stands in the centre before the woven cloth. Judging by individual details, Velázquez used the composition found in Titian's *The Rape of Europa*. Minerva is about to strike Arachne, although the moment of the woman's transformation into a spider is not shown. An oblique allusion·to the metamorphosis is contained in the musical instrument included in the scene, as music was traditionally considered to be an antidote against fear of tarantulas. The theme Velázquez explores in his *Fable of Arachne* is the condition of a mortal, who is the triumphant equal to the gods in artistic talent, but still helpless before their power.

Velázquez also painted mythological works for the Hall of Mirrors in the Alcázar. He completed the decorative works in 1658 when the Bolognese artists Angelo Michele Colonna and Agostino Metelli arrived in Madrid to produce the ceiling paintings, as agreed with Velázquez during his stay in Italy. Velázquez himself created four large, narrow paintings which were installed between the windows. Three of them perished in a fire; only *Mercury and Argus* (*ca* 1659; Prado Museum) has survived. The painting's composition imposed by the work's format, its unusual and complicated foreshortening of the figures, its lighting effects and its virtuoso execution, place this work among the painter's masterpieces. During his second visit to Italy, Velázquez petitioned to be made a member of one of the knightly orders. His wish was only acknowledged in 1658. The Council of Orders demanded proof of the artist's noble origin and that he had not received money for his work. One hundred and forty-eight witnesses, including people from Seville and from regions bordering Portugal, where the artist's ancestors had lived, gave evidence. Zurbarán and Cano, who had both known the artist since his youth, came specially to Madrid from Seville. The Council twice rejected Velázquez's candidacy. In view of the insufficiency of the witnesses' testimony, it demanded special permission from the Pope to confer the title of *hidalgo* on the artist. At last, on 28 November 1659, Velázquez was made a Knight of the Order of Santiago. At that time peace negotiations with France were underway. One of the chief provisions was the marriage between Louis XIV and the Infanta María Teresa. The French and Spanish rulers selected the Isle of Pheasants on the border of France and Spain for the betrothal ceremony. A pavilion was built there, and Velázquez, as King's Chamberlain, was put in charge of the decoration of the pavilion and the entire ceremonial of the meeting. The betrothal took place on 6 June 1660. On 26 June the artist returned to Madrid, where he fell seriously ill, and on 6 August he passed away. Eight days later his wife and lifelong friend, Juana de Miranda, also died.

# VELÁZQUEZ – ONE OF THE GREATEST PAINTERS
## OF THE SEVENTEENTH CENTURY

Out of three clearly expressed trends of the Baroque period – the classical, which reached its apogee in the works of Poussin; the decorative-allegorical, brilliantly manifested in the art of Rubens; and the realistic – Velázquez undoubtedly belonged to the last. He began working as an artist in Seville, a city with no strictly defined artistic canons, at the time when there was a heightened interest in realistic trends. Taking a great delight in the portrayal of the world around him from his youth onwards, Velázquez retained an acute, spontaneous perception of reality, irrespective of whether he painted portraits or a work on a religious, mythological, historical or everyday subject. He shared the concern with the representation of space and painterly technique common to the best Baroque artists, but subordinated them to his own distinctive view of the world.

Velázquez lived at the court of an absolute monarch in a country where an authoritarian Catholic Church reigned supreme. The social state of mind did not encourage an interest in the private realm. Although he profoundly revealed the characters of the subjects of his portraits, Velázquez nonetheless remained reserved, not fully unveiling their inner world. Even in the more intimate portraits, a certain distance always remains between the model and the viewer. But this reticence has its own special attraction. A free, bold manner of painting made Velázquez an artist of unsurpassed genius. In the nineteenth century, Edouard Manet called him "the painter of painters". Long before that, many seventeenth-century Spanish artists followed his lead. His direct successor in the eighteenth century was Francisco Goya. Velázquez belongs to those talented painters fortunate enough to be recognized during their lifetime and invariably esteemed by all subsequent generations.

*MERCURY AND ARGUS.* Ca 1659
Oil on canvas. 127 x 248 cm
Prado Museum, Madrid

## BIOGRAPHICAL OUTLINE

**1599**
6 June: Christened in Seville in the Church of San Pedro.

**1609–10**
Trains under Francisco Herrera the Elder.

**1611**
September: Moves to the school of Francisco Pacheco.

**1617**
14 March: Passes examination for the title of Master.

**1618**
23 April: Marries Pacheco's daughter, Juana de Miranda.
*An Old Woman Cooking Eggs* and *Kitchen Scene with Christ in the House of Martha and Mary.*

**1619**
18 May: Velázquez's daughter Francisca is christened.
*The Adoration of the Magi.*

**1620**
Takes Diego de Melgar as a pupil.
Portrait of the nun Jerónima de la Fuente.

**1621**
1 January: Velázquez's daughter Ignacia is christened.
Philip IV accedes to the throne.

**1622**
Journey to Madrid.
Portrait of Luis de Góngora.

**1623**
January: Return to Seville.
August: Departure for Madrid.
6 October: Appointed Court Painter.

**1627**
Participates in a competition for a painting on the subject *The Expulsion of the Moriscos,*

which he wins. 7 March: Appointed
Gentleman Usher to the King.

1628
September: Rubens arrives in Madrid
on a diplomatic visit.

1629
April: Rubens leaves Spain for England.
10 August: Velázquez sails from Barcelona
to Italy. 23 August: Reaches Genoa from
where travels to Venice, Ferrara and Rome.
October: Prince Baltasar Carlos is born
in Madrid.

1630
In Rome. Paints a self-portrait (lost),
*Apollo in the Forge of Vulcan* and *Joseph's
Blood-stained Coat Brought to Jacob*.
Autumn: Leaves Rome for Naples.

1631
Return to Spain.
Portrait of Prince Baltasar Carlos.

1633
Velázquez's daughter, Francisca, marries Juan
Bautista Martínez del Mazo. October: Together
with Vicente Carducho inspects the quality
of royal portraits in the palaces.

1634
Hands over his post as Gentleman
Usher to Martínez del Mazo.
*Prince Baltasar Carlos on Horseback*.
April: Completes battle scenes for the Hall
of the Kingdoms in the Buen Retiro Palace.

1635
*Prince Baltasar Carlos as Huntsman*.
The triumphal entry of the Cardinal Infante
Ferdinand into Antwerp.
The war with France begins.

1636
28 July: Receives the appointment
as Gentleman of the Wardrobe.

1638
Portrait of the Duchesse de Chevreuse (lost).
Alonso Cano arrives in Madrid from Seville.

24 August: With Juan de Pareja acts
as a witness when Cano transfers property
to his father.
20 September: The Infanta María Teresa
is born.
16 October: Velázquez's granddaughter,
Inés Manuela de Silva, is christened.
Portrait of Francesco I d'Este,
Duke of Modena.

1640
A fire in the Buen Retiro Palace.
Travels to Old Castile with Cano in search
of paintings for the Buen Retiro Palace.
Rubens dies. Philip IV acquires the Flemish
artist's works at the posthumous auction.
18 March: Velázquez's grandson, José,
is christened.

1641
The Cardinal Infante Ferdinand dies
in Brussels.

1642
29 May: Velázquez's grandson, Diego,
is christened.

1643
6 January: Receives the appointment
as Gentleman of the Bedchamber.
17 January: Accompanies
Conde-Duque de Olivares into exile.
Martínez del Mazo is appointed Painter
to Prince Baltasar Carlos.

1644
February to October: Among the King's
retinue in Aragón. Portraits of
*The Dwarf Diego de Acedo, called "El Primo"*
and *Philip IV at Fraga*.
6 October: Queen Isabel of Bourbon dies.
27 November: Francisco Pacheco dies
in Seville.

1645
9 January: Velázquez's grandson, Baltasar,
is christened.

1646
9 October: Prince Baltasar Carlos dies.

## 1648
13 January: Velázquez's granddaughter,
María Teresa, is christened.
8 November: Leaves Madrid for Málaga.

## 1649
21 January: Sails from Málaga to Genoa.
The new Queen, Mariana of Austria, arrives
in Madrid.

## 1650
January: Elected a member of the Academy
of Saint Luke in Rome. 19 January: Accepted
into the Congregazione dei Virtuosi in Rome. In
Rome, paints the portraits of Pope Innocent X,
Cardinal Pamphili, Monsignor Camillo
Massimi, Juan de Pareja and others.

## 1651
23 June: Returns from his Italian journey.
12 July: The Infanta Margarita is born.

## 1652
November: Appointed chief Chamberlain
of the Imperial Palace.
6 November: Velázquez's grandson,
Melchor Julián, is born.

## 1654
Velázquez's daughter, Francisca, dies.
Renovation of the decoration of the Escorial
begins.

## 1655
Velázquez's family moves to the Casa
del Tesoro next to the Alcázar.

## 1656
Paints his masterpiece *Las Meninas*.

## 1657
Prince Philip Prosper is born.

## 1658
Completion of the work in the Hall
of Mirrors.

## 1659
28 November: Installed as a Khight
of the Order of Santiago.
The portraits of Prince Philip Prosper
and the Infanta Margarita in blue
are sent to Vienna.

## 1660
6 August: Velázquez dies.